THE HAND

DIE HAND

LA MAIN

SKETCH BOOK **THE HAND**

DIE HAND SKIZZENHEFT

CARNET DE DESSINS **LA MAIN**

Bibliothèque de l'Image

Translation in english:
Ian Monk.

Übersetzung ins deutsche:
Valérie Donnat.

© 2000, Bibliothèque de l'Image
46 bis, passage Jouffroy - 75009 Paris.
Tél : 01 48 24 54 14 - Fax : 01 45 23 08 83

Edition in english: ISBN 2-909808-82-3
Deûtsche ausgabe: ISBN 2-909808-83-1
Édition en français : ISBN 2-909808-69-6
Imprimé en Chine

PREFACE

After the face, the hand is the part of the human body which is the most independent, the most distinctive and the most particular. The fact that we almost constantly have our own hands before our eyes, and that the hands are often the only visible part of the bodies around us, lends them a deceptive familiarity. In fact, they almost seem to be possessed of a life force of their own, as though they were extremely agile creatures stuck on the ends of our arms. Whether at work or at rest, they are a constant presence, standing as a sort of signature for the person's independent existence. Aristotle compared them to the soul, because they are a kind of "instrument of instruments", or controlling force. But what variety lies behind that common function! Whatever the age, profession or position, there is an infinite number of shapes and, it could be said, of characteristics. From the pianist's hands to the farmer's hands, or from those of a clumsy toddler to those of a skilled seamstress, there is an endless quantity of shapes and gestures, rather like a language; it is sometimes even treated as such, for example in the art of rhetoric (where the emphasizing of the speech being given, by the hands, was governed by a set of rules) or as still is the case with certain Oriental dances. But whether this choreography of the hands is codified or not, it is accompanied by a whole gamut of verbs: to grip, squeeze, brandish, hold, take, seize, show, present, salute, even hand. The hand expresses mankind's endlessly varied vitality.

It is inevitable that painters have felt passionate about depicting this part of the living

VORWORT

Von allen Körperteilen des Menschen ist die Hand, unmittelbar nach dem Gesicht, der selbstständigste, der eigentümlichste und der merkwürdigste. Die Tatsache, dass wir beinahe ständig unsere eigenen Hände vor Augen haben, wie auch, dass sie oftmals die einzig sichtbaren Körperteile der uns umgebenden Menschen sind, verleihen ihnen eine Vertrautheit, die allerdings trügerisch ist. In der Tat scheinen die Hände ja selbstständig zu existieren, als wären sie sehr geschickte Lebewesen am Ende unserer Arme. Ob sie nun gerade in Bewegung sind oder in Ruhestellung, sie sind stets vorhanden und bezeichnen das Wesen und die Persönlichkeit wie ein selbstredendes Erkennungszeichen. Aristoteles verglich die Hand einmal mit der Seele, denn sie sei wie diese ein "Instrumenten-Instrument", das heißt eine Organisatorin. Doch was für ein Abwechslungsreichtum birgt sich in der Gesamtheit ihrer Funktionen! Unabhängig vom jeweiligen Alter, Beruf oder Verhalten besitzt sie eine grenzenlose äußerliche und, so könnte man sagen, charakterliche Vielfalt. Eine schier ausufernde Bandbreite von Formen und Gestiken eröffnet sich von der Hand eines Pianisten bis zu der eines Bauern, von der Hand eines unbeholfenen kleinen Kindes bis zu der jener Frauen, die man zu recht "kleine Hände" nennt; sie haben einen Eigenwert im Ausdruck und wurden auch manchmal so eingeschätzt, man denke nur an die Rednerkunst, bei der die Unterstützung des Gesagten durch Handbewegungen genauen Regeln unterworfen war, oder an die noch heute praktizierten Tänze des Orients. Zur Beschreibung der Handbewegungen gibt es, gleichgültig ob sie vorgeschrieben sind oder nicht, ein ganzes Register von

PRÉFACE

De toutes les parties du corps humain, la main, juste après le visage, est la plus autonome, la plus individuée, la plus singulière. Le fait que nous ayons presque constamment nos propres mains sous les yeux, comme le fait qu'elles soient souvent la seule partie visible du corps de ceux qui nous entourent leur confèrent une familiarité qui est pourtant trompeuse. En effet, elles n'en semblent pas moins vivre dans le monde par elles-mêmes, tels des animaux très habiles que nous aurions au bout des bras. Ouvrières ou au repos, elles sont là, manifestant l'être et la personne comme une signature indépendante. Aristote les a comparées à l'âme, parce qu'elles sont comme elle « instrument d'instruments », c'est-à-dire ordonnatrices. Mais derrière cette communauté de fonctions, quelle variété ! Par-delà l'âge, le métier, l'attitude, une infinité de formes et, pourrait-on dire, de caractères. De la main de pianiste à la main paysanne, de celle du petit enfant malhabile à celle de ces femmes qu'on appelle justement « petites mains », tout un foisonnement de formes et de gestuelles qui vaut pour langage et qui est parfois traité comme tel, comme ce fut le cas dans l'art oratoire (où le soutien apporté par la main au discours avait ses règles) ou comme c'est le cas encore dans les danses de l'Orient. Mais qu'elle soit ou non codifiée, cette chorégraphie des mains opère selon tout un usinage de verbes qui vont avec elle: agripper, serrer, brandir, tenir, prendre, tendre, empoigner, montrer, présenter, saluer, prier - la main conjugue le vivant, la main sans fin exprime et raconte.

body which is at once form, language and a tool - their tool in fact. Particularly because the hand, like the face, is difficult to render. Over and above the magical rite that saw men press it, covered with coloured matter, onto the walls of their caves, or the path that every child traces round it with a crayon on a piece of paper, the hand as a motif suggests and promotes an entire set of variations, or an obsessive repetition of forms and shapes, in the sidelines of a painting. It is as if the instrumental creator of the drawing became its motif, as though the hand, before getting down to business, started out by taking itself or its brothers as its subject. Thus it is that, with thousands of pages of studies, we have a panoply of postures which, throughout history, constitute an extraordinary ballet in which every painter, or nearly, has added his solo or *pas de deux*.

The importance given to the hand can be seen everywhere, but perhaps first of all in that sort of preparatory study (as here with Van Dyck) where a hand appears in front of a figure to pick up and correct a gesture which was initially merely sketched in. Or else, it is a posture which stands out as a figure in its own right, such as Giambattista Tiepolo's beautiful drawing of a hand brandishing a dagger. Or it can be, as in the case of the Watteau plate, a multitude of trial sketches which seem to be fingering their way through space. Sometimes the hand is shown to be indolent, having something of the sloth about it, as is the case with the Delacroix study for *Francesca da Rimini*, sometimes it seems to be severed and already dead, as in the left hand with half-opened fingers which Géricault, copying a child's ap-

Tätigkeitswörtern: anfassen, drücken, winken, halten, nehmen, hinstrecken, packen, zeigen, vorführen, grüßen, beten – die Hand bestimmt das Handeln des Menschen, die Hand drückt beständig etwas aus und erzählt.

Geradezu zwangsläufig mussten die Maler für diese Offenbarung des Wesens, die zugleich Form, Sprache und Werkzeug und nicht zuletzt auch ihr Werkzeug ist, eine besondere Begeisterung entfalten, um so mehr, als die Hand, ähnlich wie das Gesicht, schwer wiederzugeben ist. Jenseits der magischen Beziehung, die sie – mit Farbe bestrichen – auf die Wände von Höhlen drücken ließ, jenseits des von allen Kindern praktizierten Brauches, ihre Umrisse durch Umfahren ihrer Konturen mit einem Bleistift auf ein Blatt Papier zu bannen, lädt die Hand als Motiv ein und regt an zu einer ganzen Bandbreite von Spielarten, einer ganzen einprägsamen Wiederholung von Effekten und Haltungen. Und alles geht so, als würde die Ausführerin der Zeichnung zum Motiv, als wählte sie sich oder die anderen Hände, ehe sie sich an den Akt wagt, selbst zum Thema. Daraus entstand eine Unmenge von Studienblättern mit Haltungen, die im Laufe der Geschichte ein erstaunliches Ballet bilden, zu dem beinahe jeder Maler seinen Solotanz oder seinen Pas de deux beisteuerte.

Überall stellt man fest, welche Bedeutung der Hand zugeschrieben wurde, aber zunächst einmal vielleicht in jenem Typ der Vorstudie (wie jener hier wiedergegebenen von van Dyck), wo die Hand vor dem Gesicht eine Haltung wieder aufgreift und verbessert, die zunächst nur flüchtig skizziert wurde. Einmal nimmt eine bestimmte Haltung für sich ein Bild ein, wie auf der sehr schönen Zeichnung einer einen Dolch haltenden Hand von Giambattista Tiepolo, ein

Il était fatal que pour cette manifestation de l'être qui est tout à la fois forme, langage et outil, et qui est leur outil, les peintres aient conçu une sorte de passion, et d'autant plus forte que la main, autant que le visage, est difficile à rendre. Au-delà du rapport magique qui l'appliqua, enduite de matière colorante, sur les parois des cavernes, au-delà aussi du geste que tous les enfants ont eu, en la détourant à l'aide d'un crayon sur une feuille de papier, la main, en tant que motif, suggère et incite, dans les coulisses du tableau, toute une gamme de variations, toute une obsédante répétition d'effets et d'allures. Et tout se passe comme si l'exécutrice du dessin en devenait le motif, comme si la main, avant de passer à l'acte, s'entraînait en se prenant elle-même, ou ses consœurs, pour sujet. De telle sorte que nous avons, en des milliers de feuilles d'étude, toute une volière d'attitudes formant, à travers l'histoire, un surprenant ballet où chaque peintre ou presque vient écrire son solo ou son pas de deux.

L'importance accordée à la main, on la constate partout, mais d'abord peut-être dans ce type d'étude préparatoire (comme celle, ici, de Van Dyck) où la main vient en avant de la figure reprendre et corriger un geste qui ne fut qu'esquissé une première fois. Tantôt c'est une attitude qui vient seule s'imposer comme figure à part entière, ainsi sur le très beau dessin de Giambattista Tiepolo où la main brandit une dague, tantôt, comme dans la planche de Watteau, c'est une multitude d'essais qui semble tâtonner dans l'espace. Tantôt la main est montrée indolente, ayant quelque chose d'une hermine, comme sur l'étude de Delacroix pour *Francesca da Rimini*, tantôt elle est comme cou-

proach, drew on his death bed. Sometimes it is active, like that knotty hand dexterously gripping a graver as drawn by Dürer, or else it is at rest, yet still terribly powerful and present, as in Monsieur Bertin's right hand, where Ingres's ideal vision has been tempered by some unaccustomed realism.

What comes out most clearly from such an album of hands is the impossibility for the artist, regardless of the efforts he makes and of his genius, to escape from that well-worn path which he must continually pace and constantly resume. And it is a moment of truth when, in this patient exercise, the ever-faithful hand comes to his aid. Hands in painting - whether they be lyrical, delicate, lively and alert, or else violent, nervy and tragic - are never mere details, as can be seen in these drawings, but are focal points which contain and distribute the energy of a picture. Each hand is always latently the one which, in Picasso's rapid Hamlet-like sketch, is holding a skull. The hand is life holding the symbol of death and, in the multiple ways painters have looked at it, something of this lives on in every epoch or style, something which has a bearing on what is least affected and most open in the figurative approach.

anderes Mal, wie auf dem Gemälde von Watteau, scheint eine Vielzahl von Studien den Raum abzutasten. Bald wird die Hand lässig gezeigt, als etwas Hermelinhaftes, wie auf der Studie von Delacroix zur Francesca da Rimini, bald ist sie aufgeschnitten und bereits tot, wie jene linke Hand mit geöffneten Fingern, die Géricault, unter Wiederaufnahme der kindlichen Vorgehensweise, in dem Bett zeichnete, das sein Sterbebett werden sollte. Einmal ist sie in Bewegung, wie jene so knorrige Hand von Dürer, die geschickt den Radierstichel führt, ein anderes Mal ruht sie, jedoch schrecklich mächtig und gesättigt wie jene rechte Hand von Monsieur Bertin, wo die Idealvorstellung von Ingres einem ungewohnten Zug von Realismus beipflichten musste.

Aus dem vorliegenden Bildband von Händen wird deutlich, wie unmöglich es zumindest für einen Künstler ist, sich den Phrasen zu entziehen, die er ewig erkundet und ewig erlernt, gleich welches seine Anstrengung und sein Können sind. Und was die Hand in dieser Geduldsübung, was die treue Hand getreu beisteuert und beiträgt, das ist eine Instanz der Wahrheit. Ob musizierend, fein, flink und munter, oder im Gegenteil gewaltsam, nervös und tragisch, die Hände in der Malerei – und das können uns die Zeichnungen belegen – sind niemals belanglose Details, sie sind vielmehr zentrale Stellen, in denen sich die Energie eines Gemäldes erweist und konzentriert. Jede Hand ist insgeheim jene, die, wie in der schnellen und hamletartigen Zeichnung von Picasso, einen Totenschädel hält. Die Hand ist das Leben, die das Zeichen des Todes hält, und in der unermüdlichen Studie der Künstler mit ihr bewahrt sich durch alle Zeiten und Stilrichtungen etwas von dem, das mit dem figurativen Akt des am wenigsten Zurechtgemachten und Nacktesten zu tun hat.

pée et déjà morte, telle cette main gauche aux doigts entr'ouverts que Géricault, reprenant le procédé enfantin, dessina dans le lit où il allait mourir. Tantôt elle agit, comme cette main si noueuse de Dürer tenant avec dextérité le burin, tantôt elle repose, mais terriblement puissante et repue, comme cette main droite de M. Bertin où l'idéal d'Ingres a dû consentir à une dose de réalisme inaccoutumée.

Ce qui ressort clairement d'un tel album de mains, c'est l'impossibilité en tout cas pour un artiste d'échapper, quel que soit son effort, son génie, au régime de phrases dont il est l'éternel arpenteur et l'éternel apprenti. Et ce que la main, dans cet exercice de patience, ce que la main fidèle vient là fidèlement seconder, secourir, c'est une instance de vérité. Musiciennes, délicates, enjouées, alertes ou au contraire violentes, nerveuses, tragiques, les mains de la peinture - et les dessins sont là pour nous le dire - ne sont jamais de simples détails, ce sont des nœuds sur lesquels se vérifie et se relance l'énergie d'un tableau. Toute main est toujours à l'état latent celle qui, comme dans le dessin rapide et hamletien de Picasso, tient un crâne. La main est la vie qui tient le signe de la mort et, dans le face-à-face éperdu des peintres avec elle, quelque chose de tel se maintient à travers les âges et les styles, quelque chose qui a à voir avec l'acte figuratif dans ce qu'il a de moins apprêté et de plus nu.

JEAN-CHRISTOPHE BAILLY

Study of hands.
Metalpoint highlighted with
white on pink paper.

Handstudie.
Silberstift, weiss gehöht
auf rosa Papier.

Étude de mains.
Pointe de métal, rehauts de blanc
sur papier préparé rose.

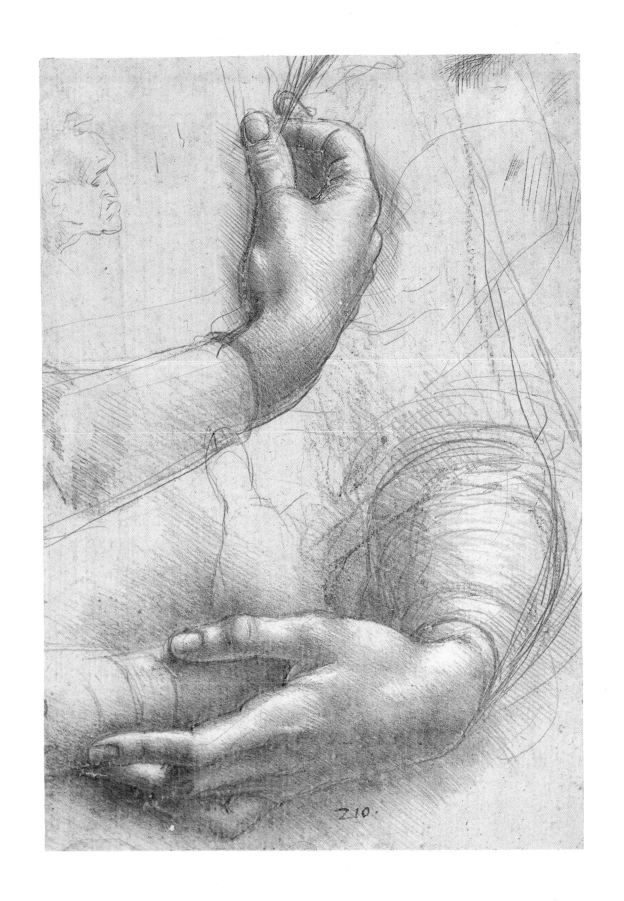

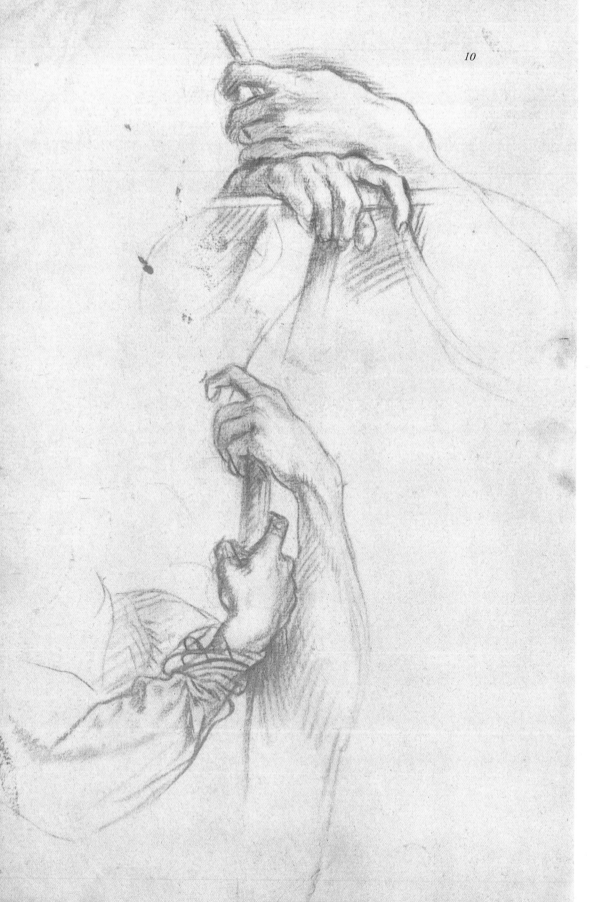

ANDREA DEL SARTO

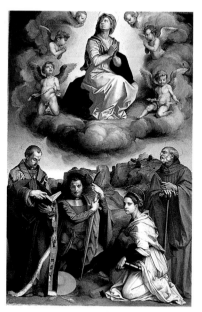

*Madonna in glory
and four saints.*
Oil on canvas.

*Madonna in Gloria
und vier Heilige.*
Öl auf Leinwand.

*Vierge en gloire
entourée de
quatre saints.*
Huile sur toile.

*Two studies of a
young man's hands.*
Red pastel.

*Zwei Studien der
Hand eines jungen
Mannes.*
Rötel.

*Deux études de
mains d'un jeune
homme.*
Pastel rouge.

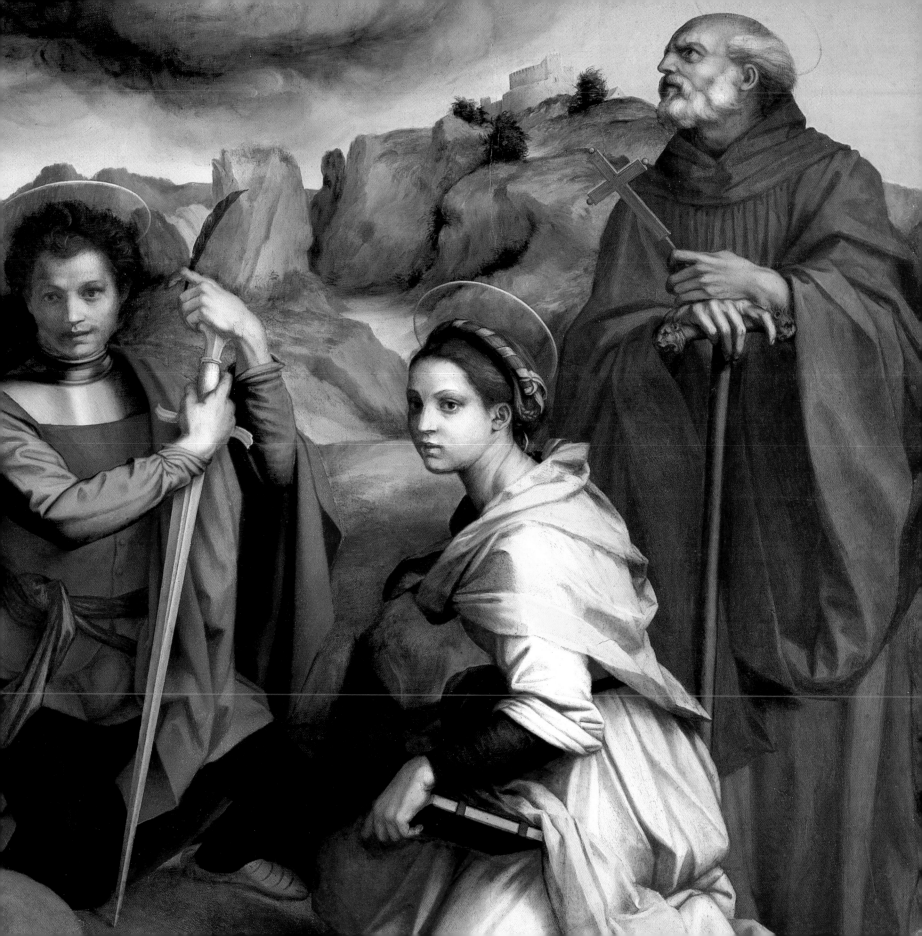

*Study of an arm and linked
hands, study for San Salvi
abbey in Florence.*
Red chalk.

*Studie eines Armes und gefalteter
Hände, Studie für die
Abtei San Salvi in Florenz.*
Rötelzeichnung.

*Étude d'un bras et de mains jointes,
étude pour l'abbaye de San Salvi
à Florence.*
Sanguine.

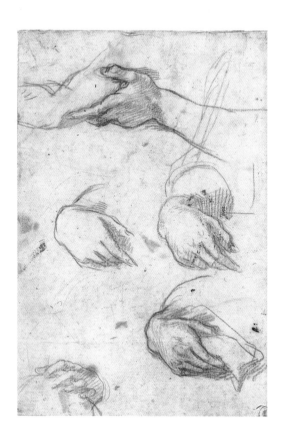 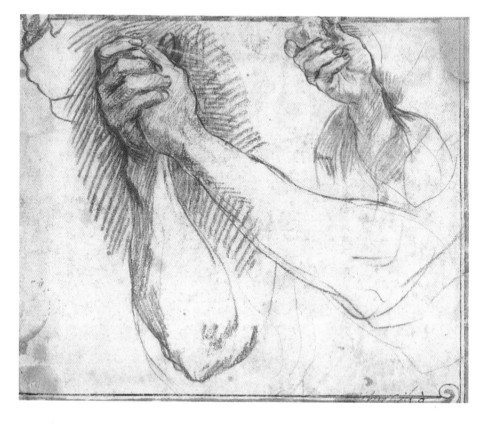

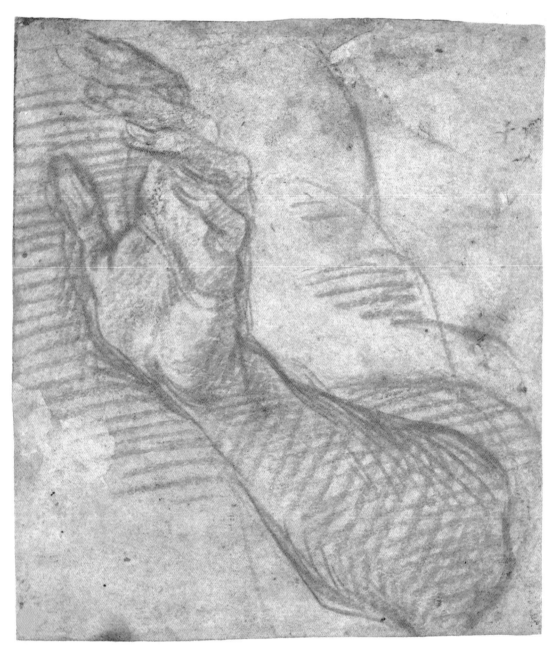

Left arm and hand.
Red chalk on beige paper.

*Linker Arm und
linke Hand.*
Rötel auf beigem Papier.

Bras et main gauches.
Sanguine, papier beige.

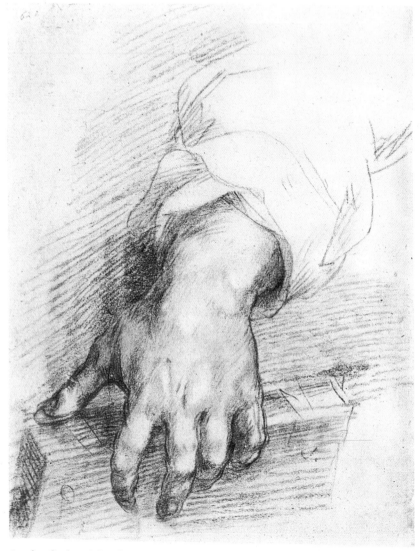

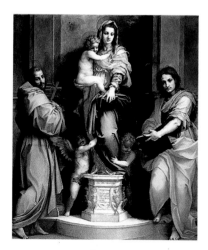

Madonna of the Harpies.
Oil on canvas.

Harpyienmadonna.
Öl auf Leinwand.

Madone des Harpies.
Peinture.

Study of a hand for the Madonna of the Harpies.
Pastel.

Handstudie für die Harpyienmadonna.
Pastell.

Étude de mains pour la Madone des Harpies.
Pastel sur papier.

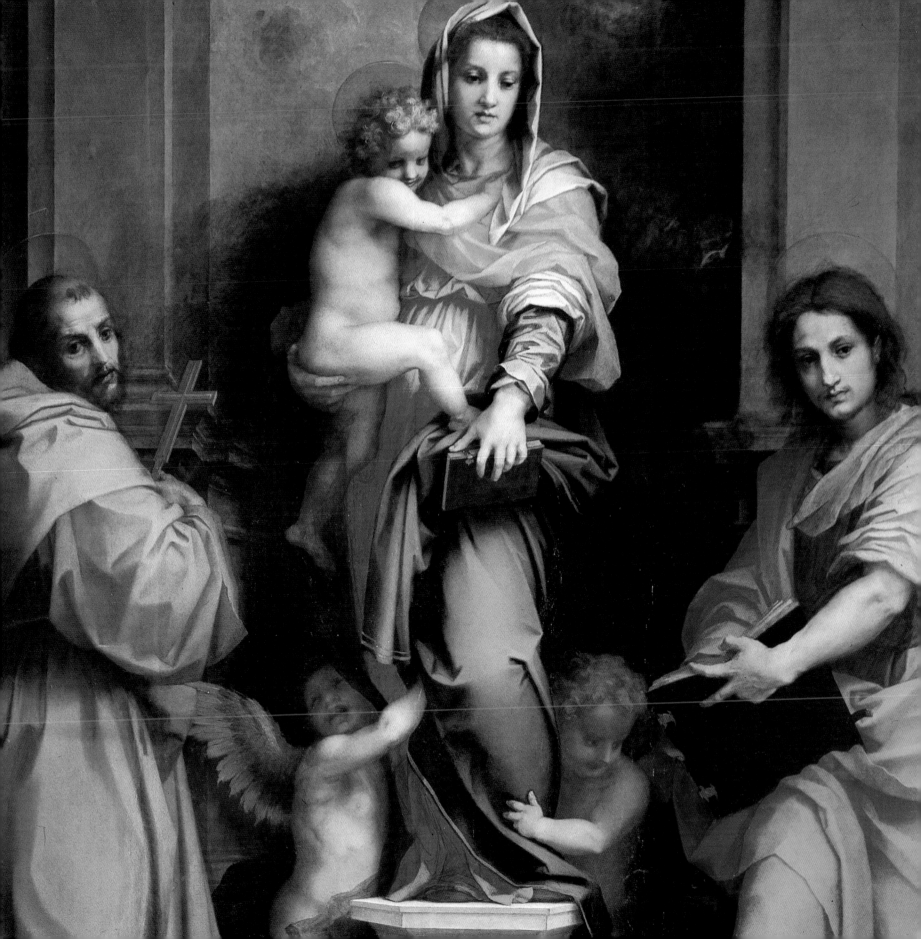

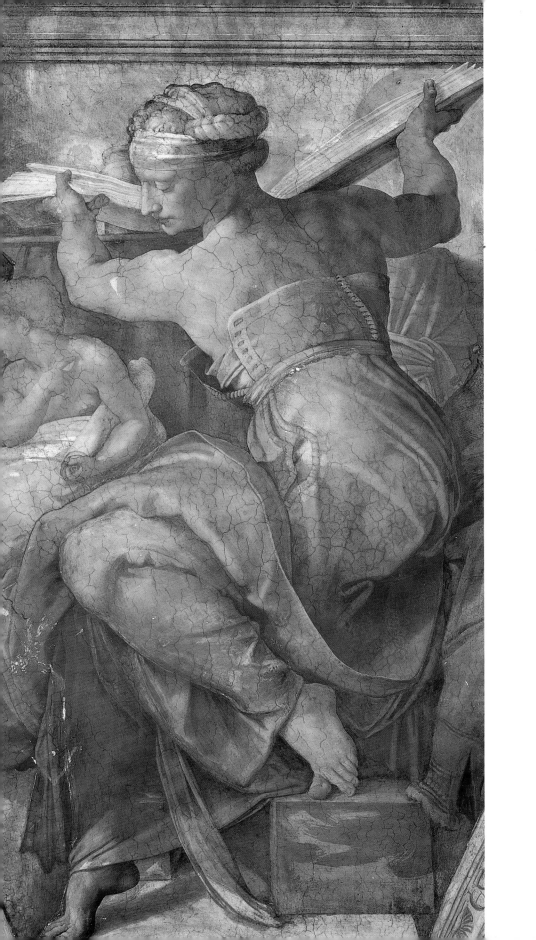

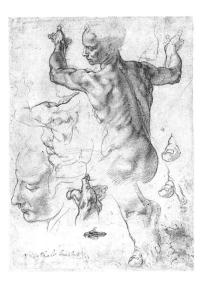

Study for the Sibyl of Libya.
Red pastel.

Studie für die Lybische Sibylle.
Rotes Pastell.

Étude pour la Sibylle de Libye.
Pastel rouge sur papier.

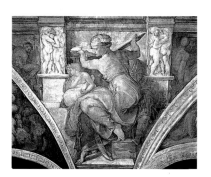

The Sibyl of Libya. Fresco.

Die Lybische Sibylle. Fresko.

La Sibylle de Libye. Fresque.

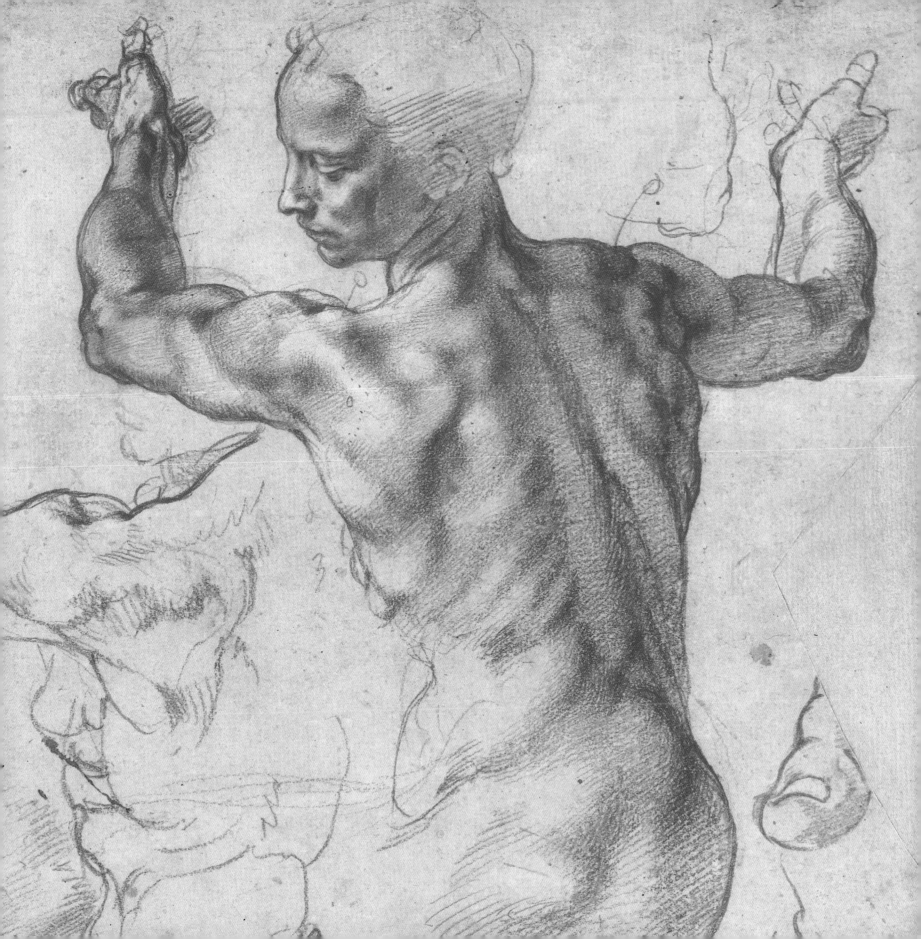

*Study for Adam in
the Sistine Chapel.*

Two shades of red chalk
and black chalk.

*Studie für die Adam-Figur in
der Sixtinischen Kapelle.*

Zwei Rötel-Farbtöne
und schwarze Kreide.

*Études pour la figure d'Adam
à la chapelle Sixtine.*

Deux tons de sanguine
et pierre noire.

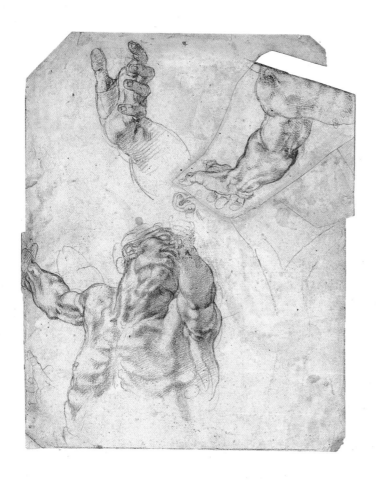

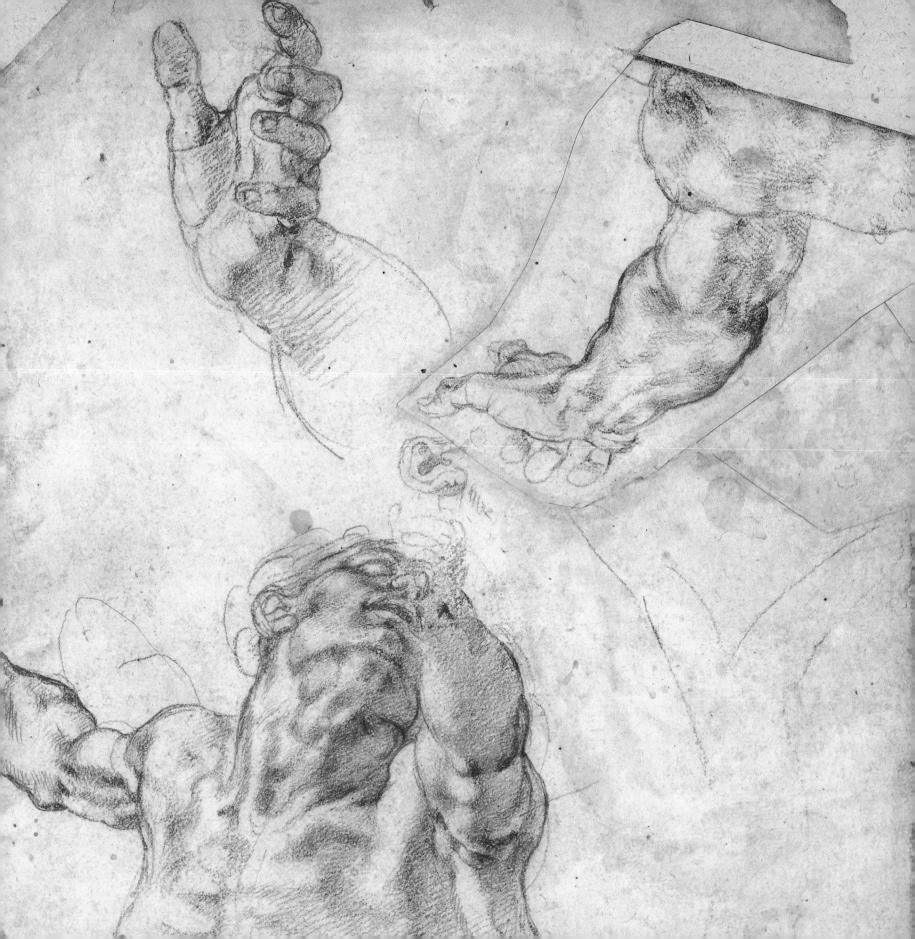

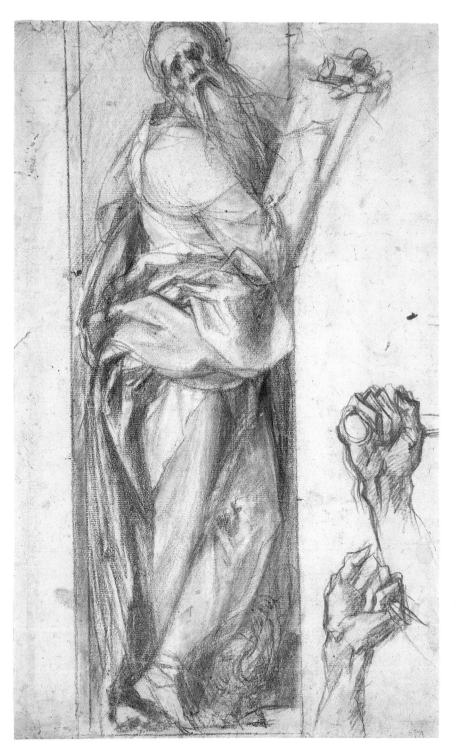

Study for Saint John and the hands of Saint Michael for the altarpiece of Saint Michael's church, Empoli.
Black pastel highlighted with white, red pastel (the hands).

Studie des heiligen Johannes und der Hände des heiligen Michael für den Hochaltar der Kirche San Michele in Empoli.
Schwarzes Pastell, weiss gehöht, rotes Pastell (Hände).

Étude de saint Jean et des mains de saint Michel pour le retable de l'église Saint-Michel à Empoli.
Pastel noir, rehaussé de blanc ; pastel rouge.

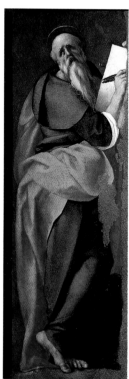

Saint John the Evangelist and Saint Michael.
Oil on panel.

Der heilige Johannes und der heilige Michael.
Öl auf Holz.

Saint Jean Évangéliste et saint Michel.
Huile sur bois.

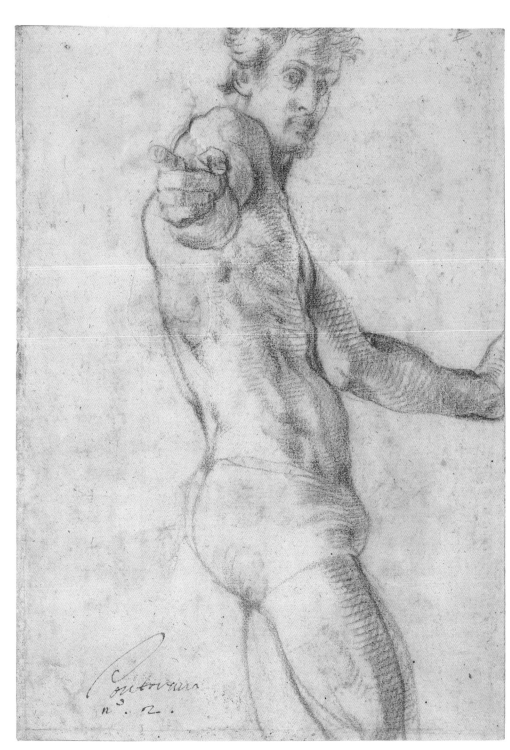

Study of nude (self-portrait).
Red chalk.

Aktstudie (Selbstporträt).
Rötelzeichnung.

Étude de nu (autoportrait).
Sanguine.

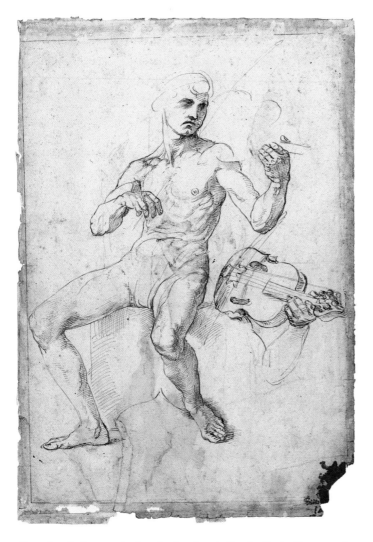

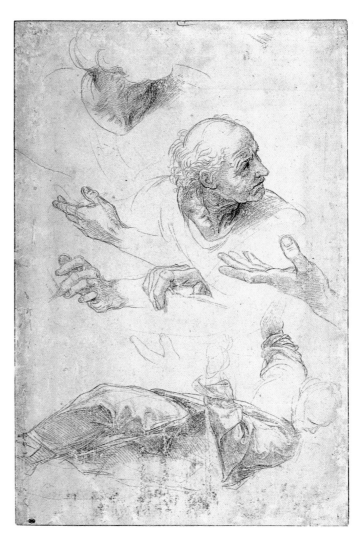

Seated naked man playing the lyre (study for Apollo in 'Parnassus' to the right, detail of arm and of the instrument).
Pen and brown ink.

Sitzender nackter Mann, auf der Handleier spielend (Studie für, „Apollo im Parnass", rechts Detail des Armes und des Instruments).
Feder, braune Tinte und Bleistift.

Homme nu assis jouant du violon (étude pour Apollon dans "Le Parnasse", à droite, détail du bras et de l'instrument.
Plume, encre brune.

Old man's head, studies of neck, right hand, three left hands and a sketch of a fourth one, as well as of a standing draped man.
Metalpoint, graphite, pen and brown ink.

Kopf eines alten Mannes, Studie eines Halses, einer rechten Hand, von drei linken Händen und Skizze einer vierten Hand sowie eines stehenden drapierten Mannes.
Metallstift, Bleistift, braune Tinte und Feder.

Tête de vieil homme, études de cous, trois mains gauches et l'esquisse d'une quatrième ainsi qu'un homme dans un drapé.
Pointe d'argent, papier préparé blanc verdâtre.

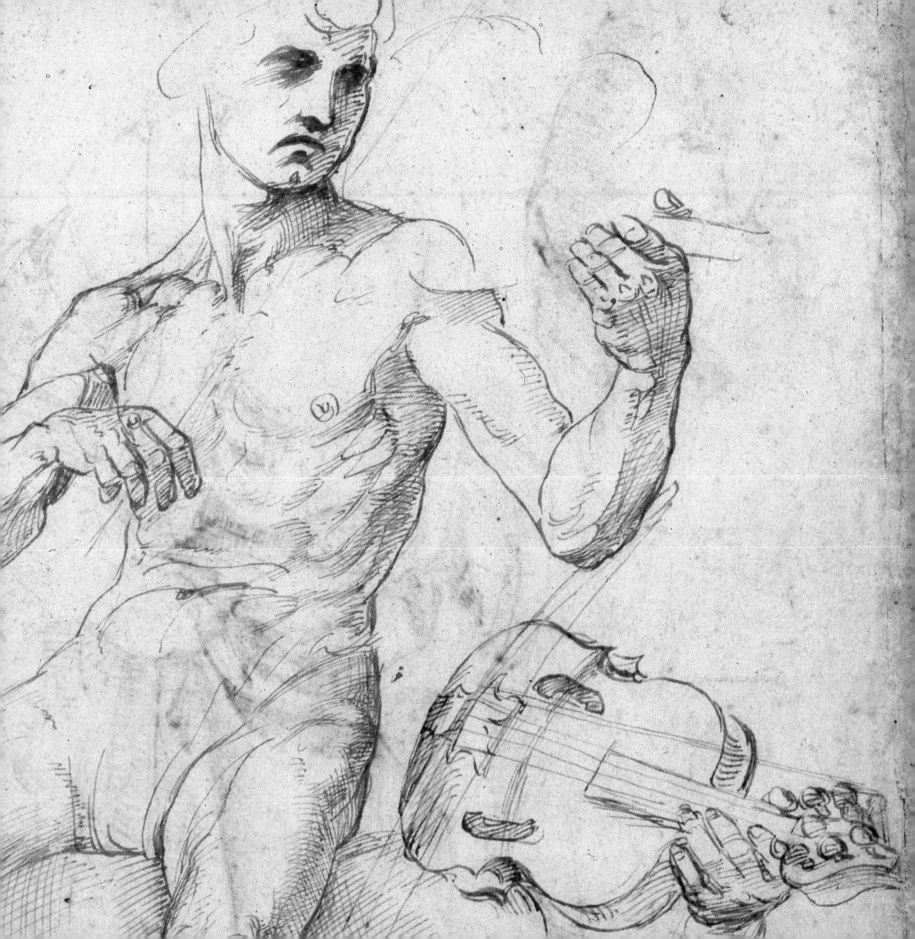

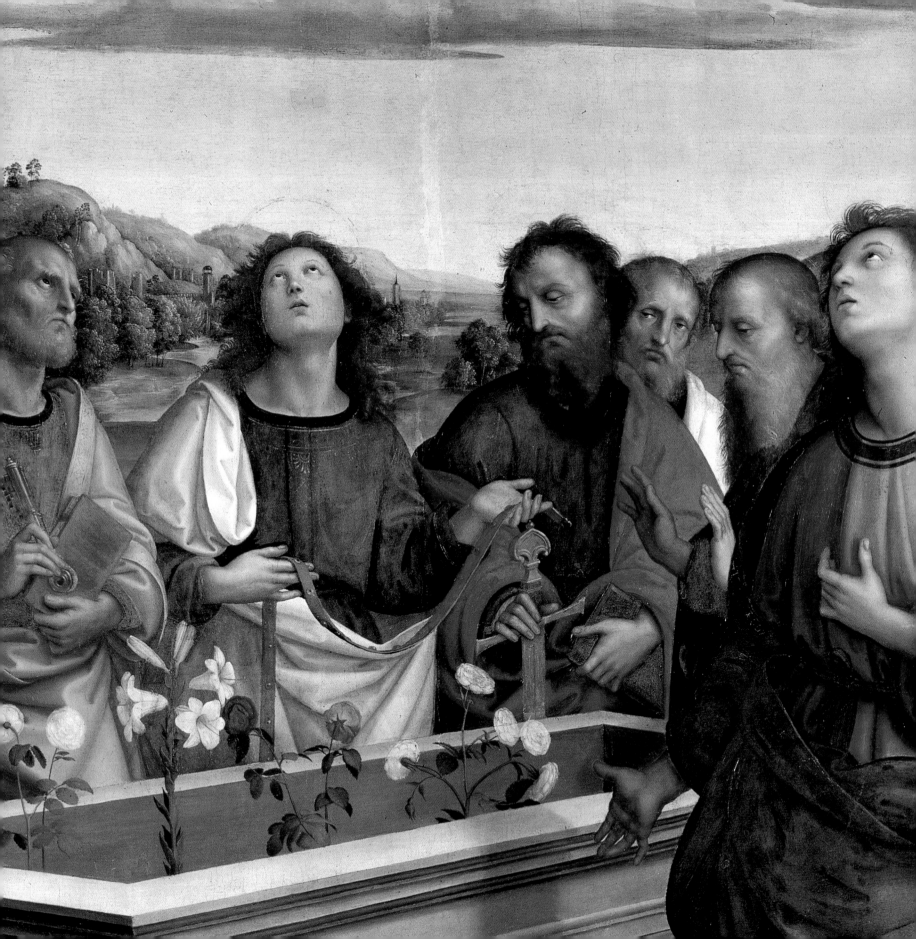

The Coronation
of the Virgin.
Oil on panel transfered on canvas.

Die Krönung Mariens.
Öl auf Holz, auf Leinwand
bertragen.

Le couronnement
de la Vierge.
Huile sur bois transférée sur toile.

Study for Saint Thomas in the
Coronation of the Virgin.
Silverpoint on grey paper.

Studie zum heiligen Thomas
in der Krönung Mariens.
Silberstift auf grauem Papier.

Étude pour saint Thomas
dans Le couronnement de la
Vierge du Vatican.
Pointe de métal sur papier gris.

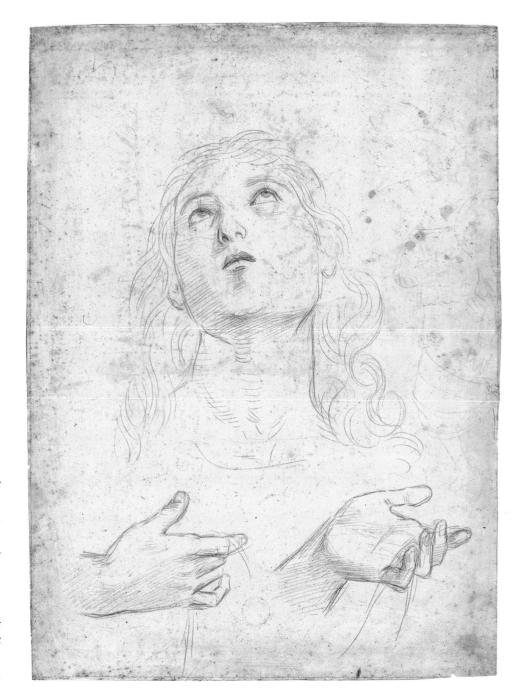

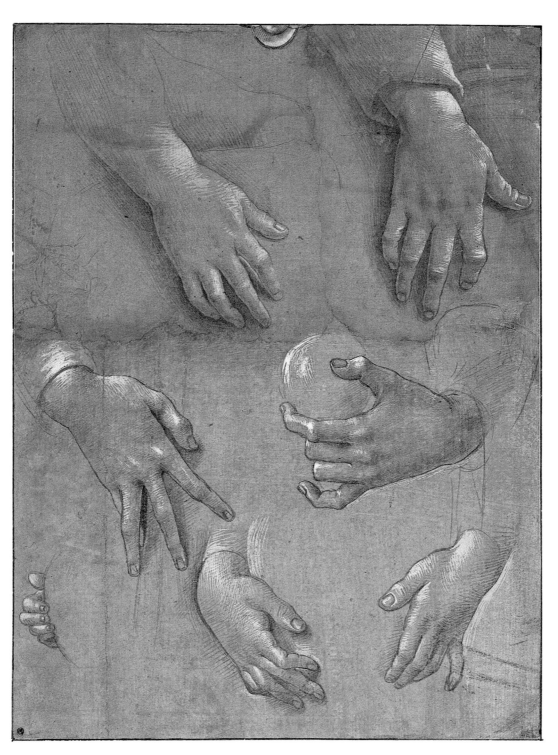

Study of hands.

Silver point highlighted with
white on grey paper, in three pieces
pasted together.

Handstudien.

Silberstift, weiss gehöht
auf grauem Papier, aus drei Teilen
zusammengesetzt.

Études de mains.

Pointe d'argent, rehauts de blanc sur
papier préparé en gris en trois
parties collées entre elles.

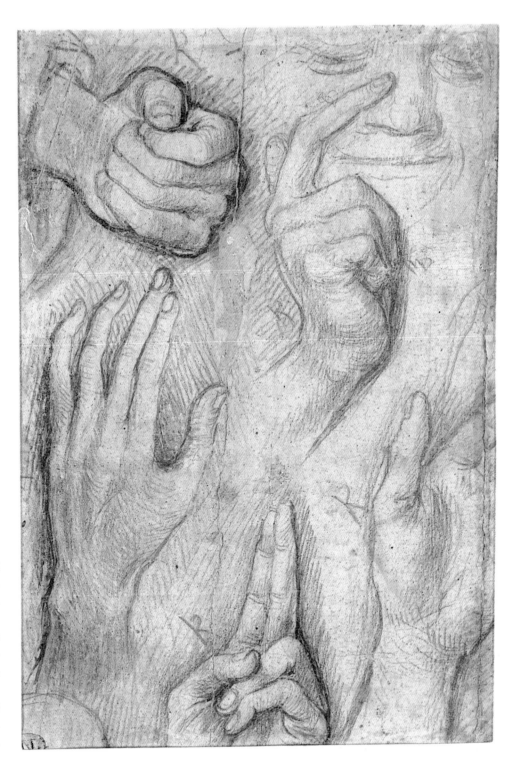

*Studies of five hands and
of a young man's head.*
Silverpoint on grey paper.

*Studie von fünf Händen und des
Kopfes eines jungen Mannes.*
Silberstift auf grauem Papier.

*Études de cinq mains et d'une
tête de jeune homme.*
Pointe d'argent, papier préparé en gris.

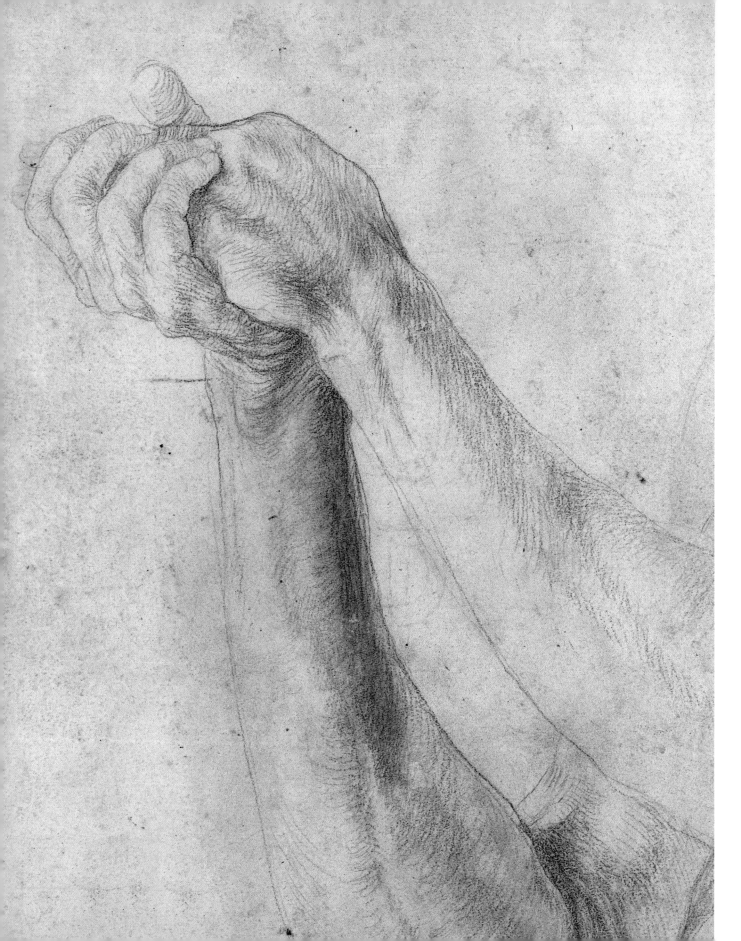

MATTHIAS GOTHARDT GRÜNEWALD

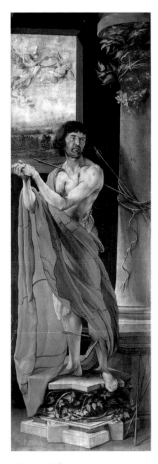

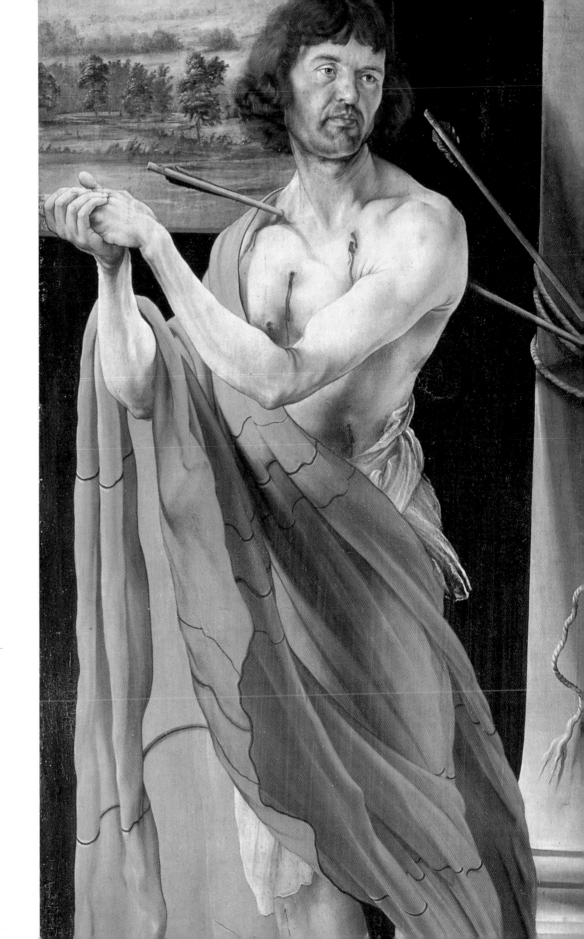

Saint Sebastian,
Issenheim altarpiece.
Oil on panel.

Der heilige Sebastian
des Isenheimer Altars.
Öl auf Holz.

Saint Sébastien,
retable d'Issenheim.
Huile sur bois.

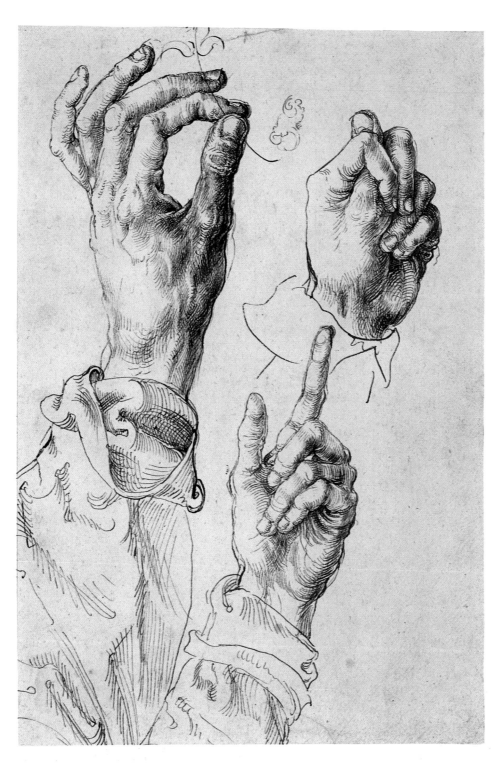

Study of three hands.
Pen and black ink.

Studie von drei Händen.
Bleistift und schwarze Tinte.

Étude de mains.
Crayon et encre noire.

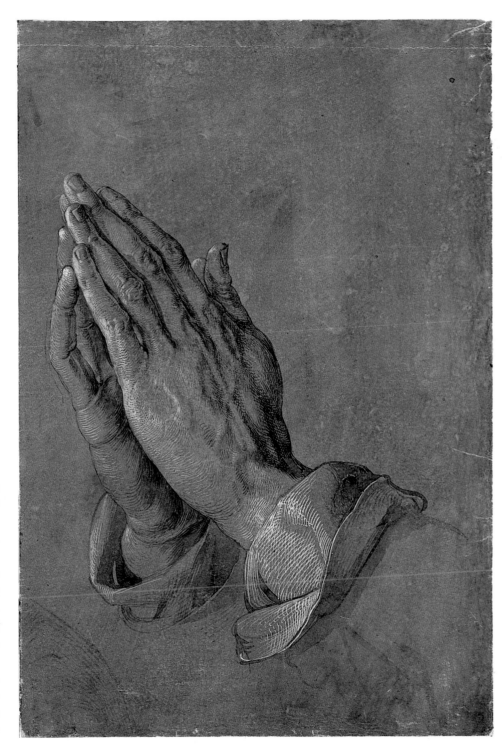

Study for the hands of an apostle
(praying posture), preparatory study
for the Heller altarpiece.
Ink and white gouache on lilac paper.

Studie zu den Händen eines
Apostels (Betende Hände) ;
Vorstudie zum Heller-Altar.
Tinte und weisse Gouache auf
bläulichem Papier.

Étude de mains en prière,
préparatoire pour le retable Heller.
Encre et gouache blanche sur
papier couleur lilas.

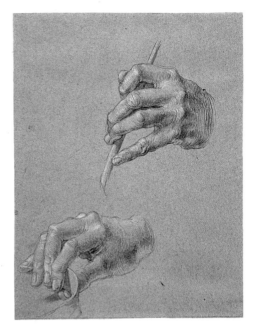

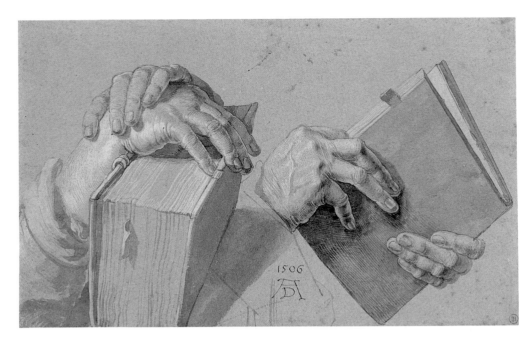

Study of hands.
Drawing on blue paper.

Handstudie.
Zeichnung auf blauem Papier.

Étude de mains.
Dessin sur papier bleu.

*Two pairs of hands
holding books.*
Brush in black ink and
wash on blue and
white paper.

*Zwei Paare von Händen,
Bücher haltend.*
Pinselzeichnung, schwarz
laviert auf blauem und
weissem Papier.

*Deux paires de mains
tenant des livres.*
Pinceau d'encre noire et lavis
sur papier bleu et blanc.

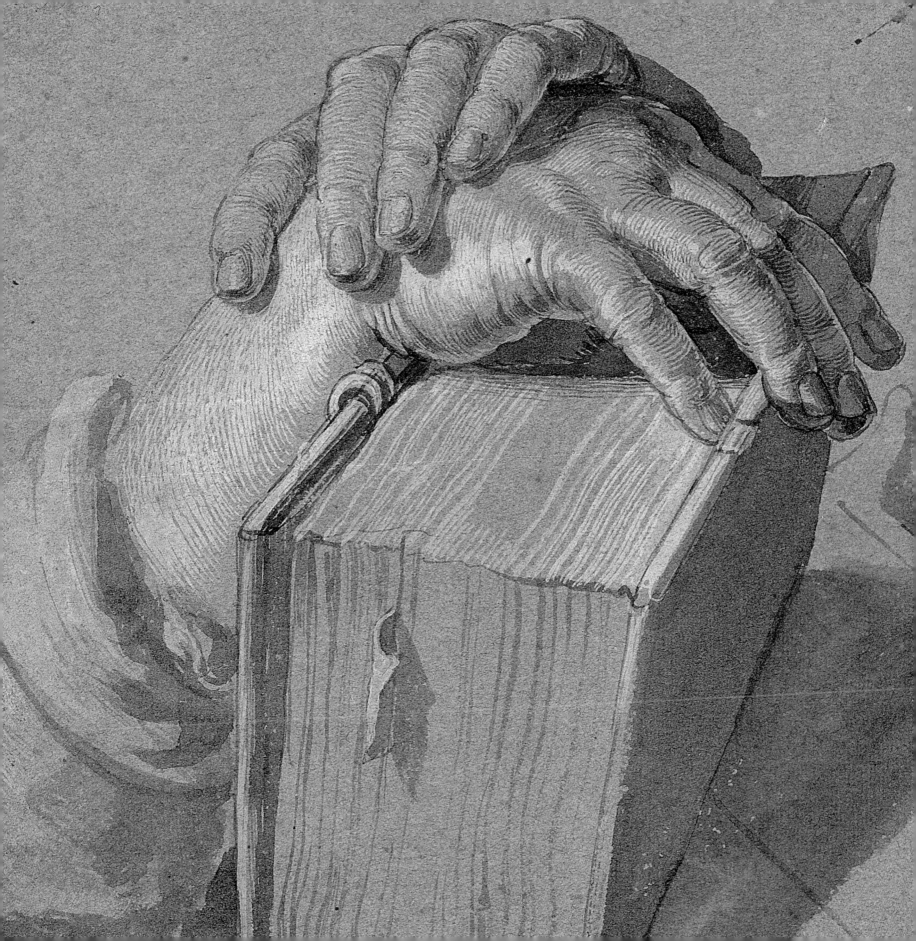

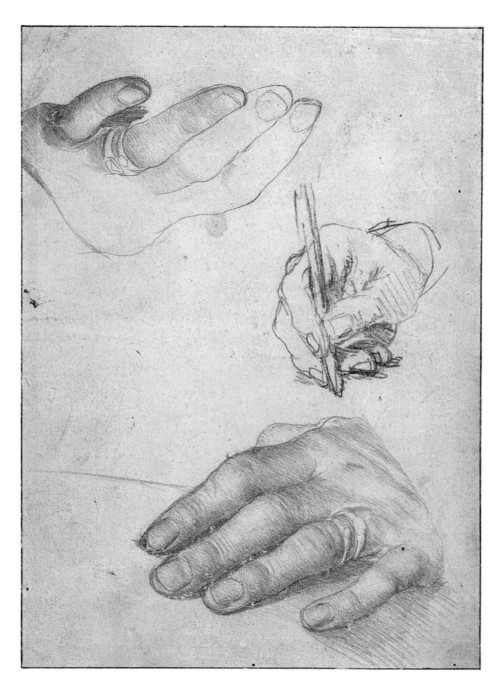

*Sheet with three studies of hands
for the portrait of Erasmus.*
White prepared paper, black chalk,
silverpoint and red chalk.

*Blatt mit drei Handstudien
für das Porträt des Erasmus.*
Gebleichtes Papier; schwarze Kreide,
Silberstift und Rötel.

*Feuille de trois études de mains
pour le portrait d'Erasme.*
Dessin, crayon et sanguine,
sur papier préparé gris-bleu.

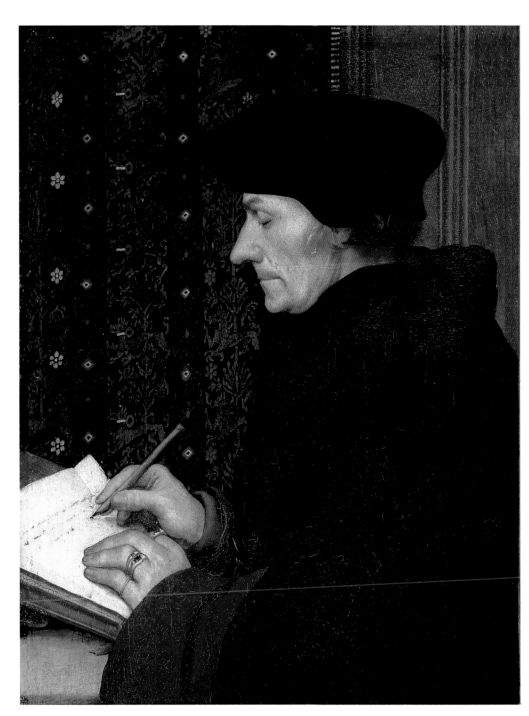

Erasmus writing.
Oil on panel.

Der schreibende Erasmus.
Öl auf Holz.

Erasme écrivant.
Huile sur bois.

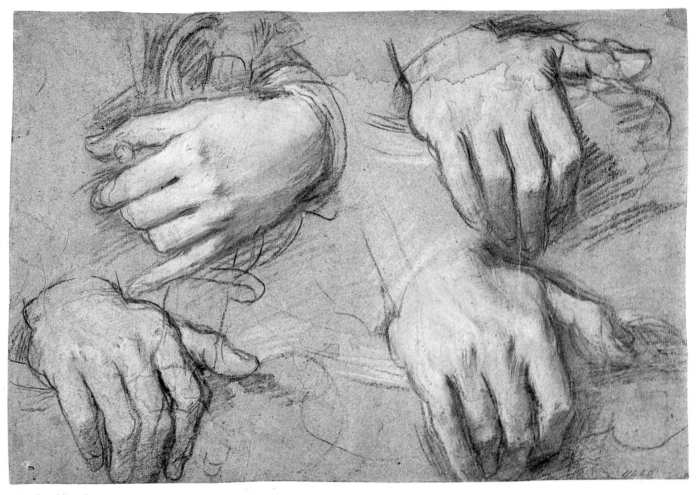

Study of hand.
Charcoal, silver-point and
red crayon on paper.

Handstudie.
Kohle, Silberweisser und roter Stift auf Papier.

Étude de main.
Fusain, pointe d'argent et
crayon rouge sur papier.

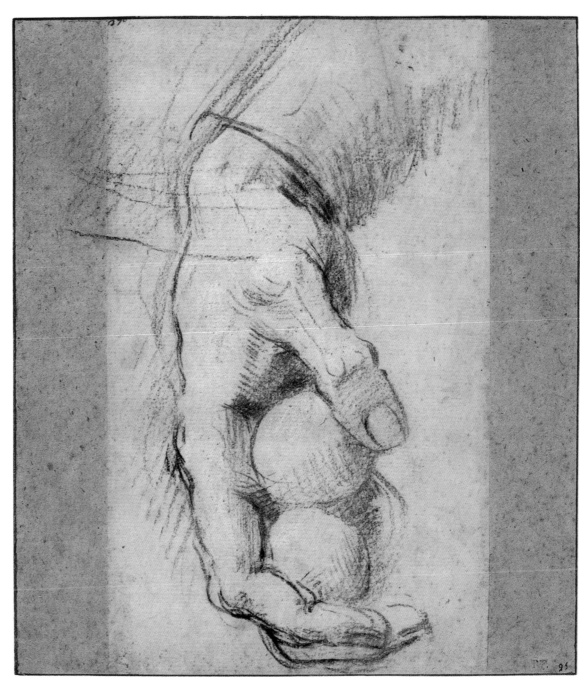

*Study of a hand
holding three balls.*
Black pastel.

*Studie von drei
Kugeln haltenden
Händen.*
Schwarze Kreide.

Étude de main.
Pastel noir.

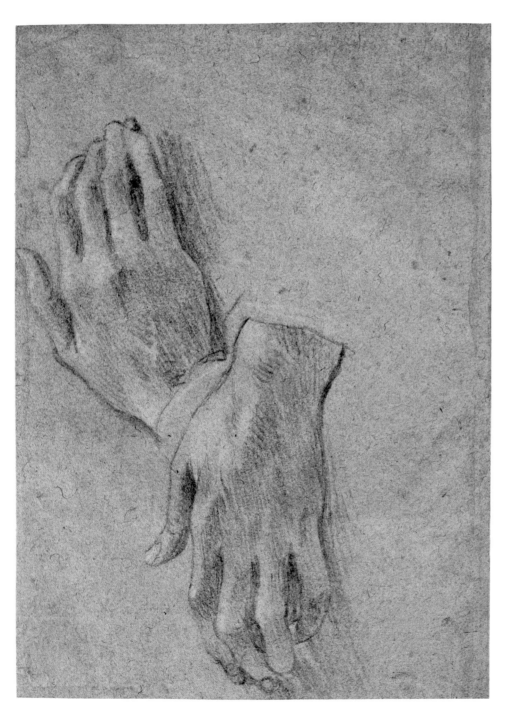

Left hand and right hand.
Black chalk highlighted with
white on blue paper.

Linke Hand und rechte Hand.
Schwarze Kreide, weiss gehöht
auf bläulichem Papier.

Main gauche et main droite.
Pierre noire, rehauts de blanc,
sur papier bleu.

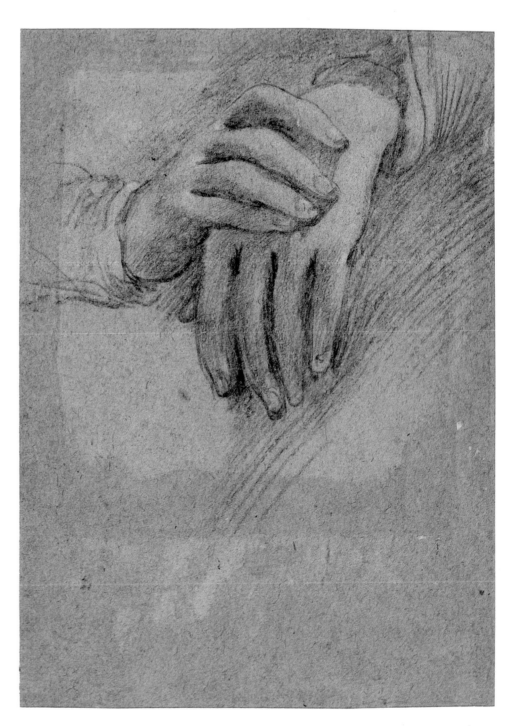

Right hand lain on left hand.
Black chalk highlighted with
white on blue paper.

*Rechte Hand, auf eine
linke Hand gelegt.*
Schwarze Kreide, weiss gehöht
auf bläulichem Papier.

*Main droite posée sur
une main gauche.*
Pierre noire, rehauts de
blanc, sur papier bleu.

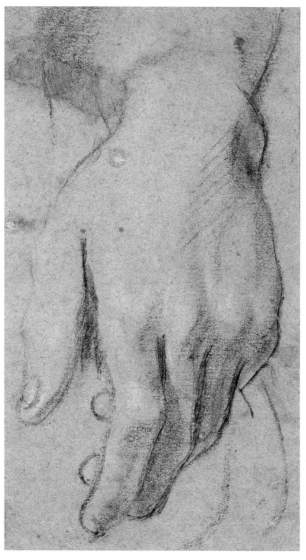

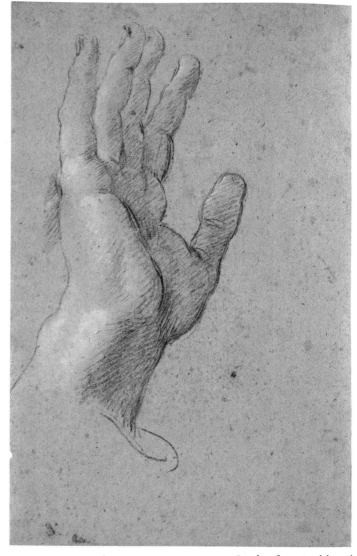

Study of a hand.
Black chalk highlighted with
white on lilac-grey paper.

Handstudie.
Schwarze Kreide, weiss gehöht
auf graublauem Papier.

Étude de main.
Pierre noire, rehauts de blanc, papier gris-bleu.

Study of a raised hand.
Black chalk highlighted with white
on lilac-grey paper.

Studie einer erhobenen Hand.
Schwarze Kreide, weiss gehöht auf graublauem Papier.

Étude d'une main levée.
Pierre noire, rehauts de blanc,
papier gris-bleu.

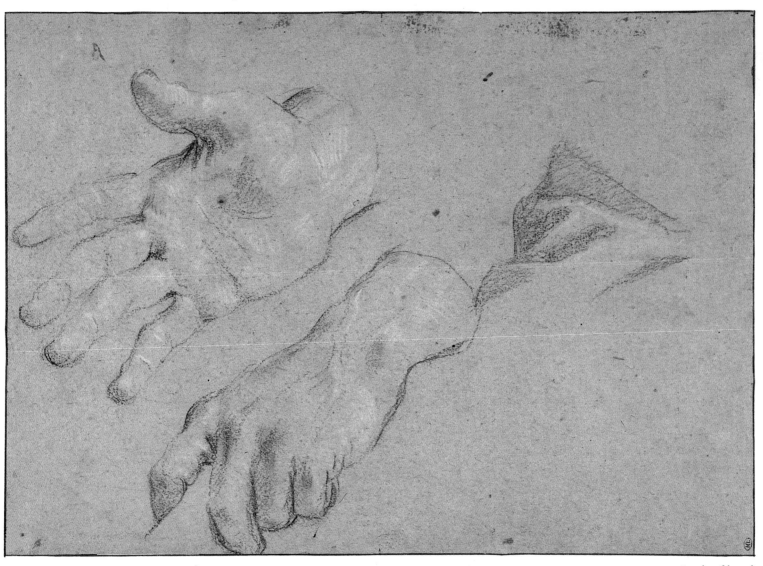

Study of hands.
Black and white crayons.

Studie von Händen.
Weisser und schwarzer Bleistift.

Étude de mains.
Crayon blanc et noir.

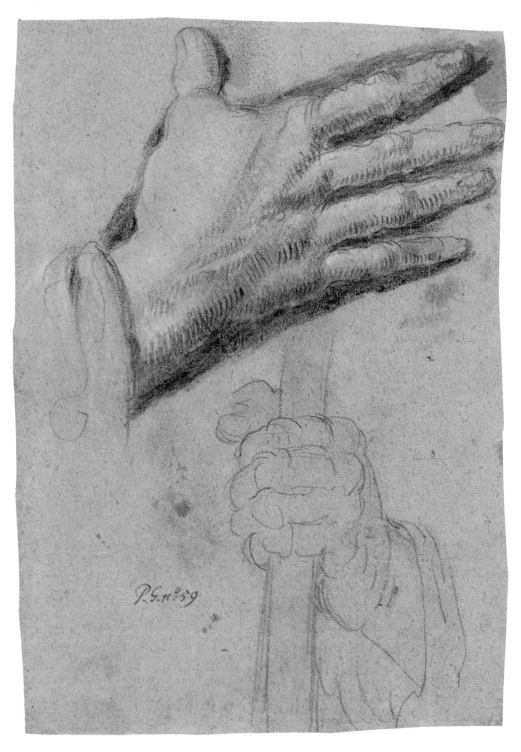

*Right hand posed and left
hand holding a stick.*
Black chalk highlighted with
white on beige paper.

*Ruhende rechte Hand und
linke Hand, einen Stock haltend.*
Schwarze Kreide, weiss gehöht
auf beigem Papier.

*Main droite posée
et main gauche
tenant un bâton.*
Pierre noire et rehauts de blanc,
sur papier beige.

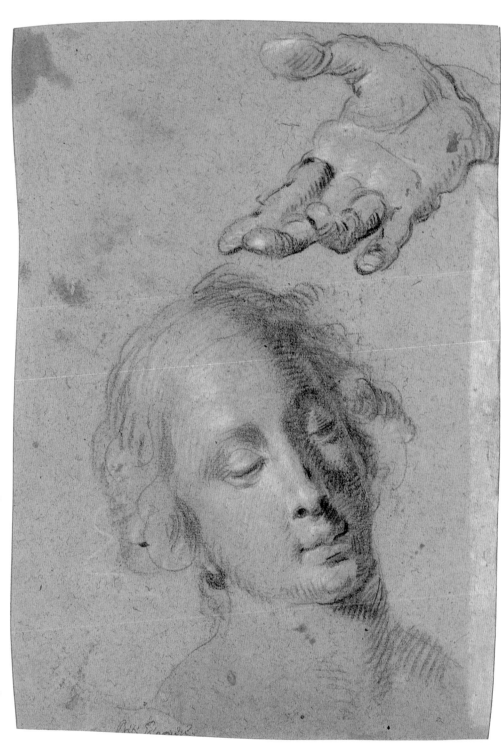

Right hand open, palm stretched upwards, and woman's head.
Black chalk highlighted with white on grey paper.

Geöffnete rechte Hand, die Handfläche nach oben gedreht, und Frauenkopf.
Schwarze Kreide, weiss gehöht auf grauem Papier.

Main droite ouverte, paume vers le haut tendue et tête de femme.
Pierre noire, rehauts de blanc, papier gris.

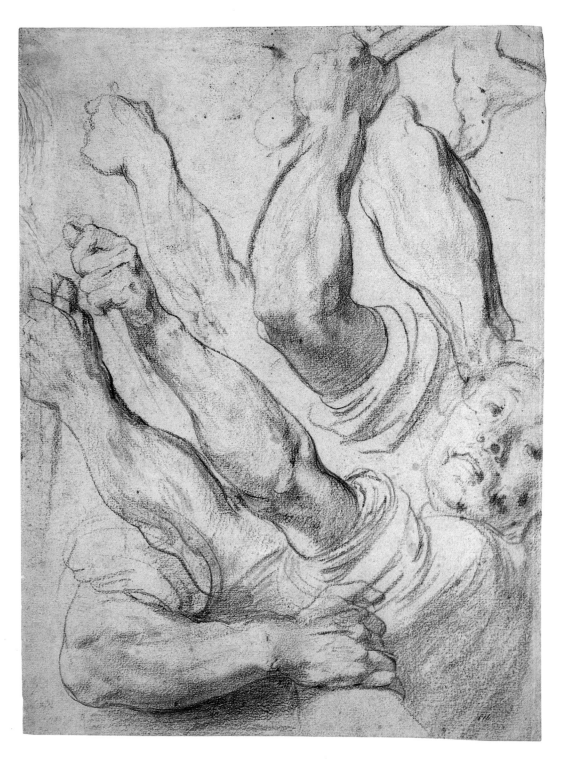

Study of arms and hands.
Chalk on fawn paper.

*Studie von Armen
und Händen.*
Kreide auf braunem papier.

Étude de bras et de mains.
Fusain sur papier brun.

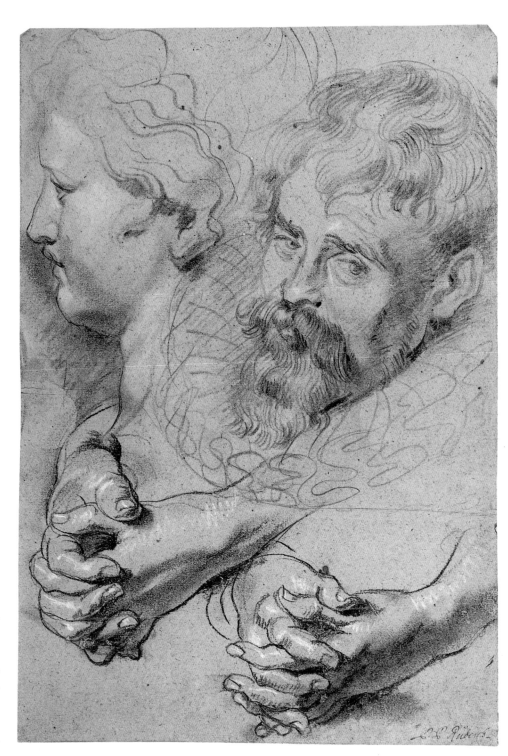

Study of heads and hands.
Black and white pastel.

Studie von Köpfen und Händen.
Schwarze und farbige Kreide
auf grauem Papier.

Étude de têtes et de mains.
Pastel noir et couleurs, papier gris.

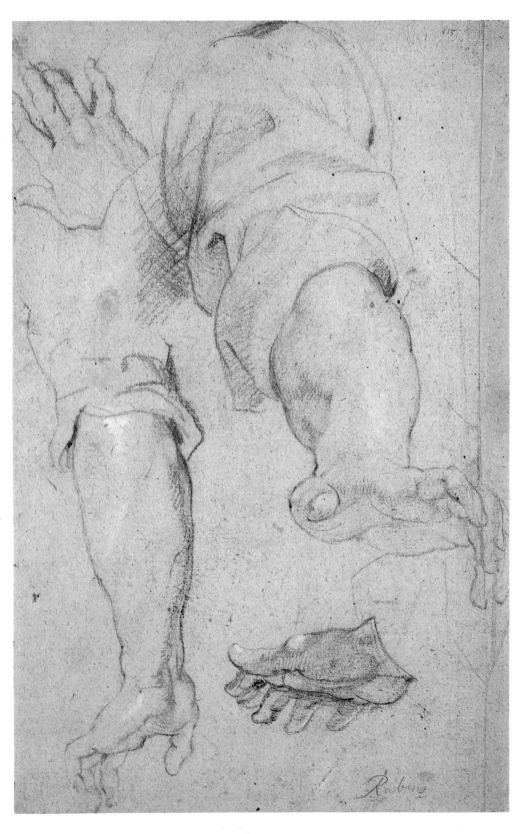

Hands.
Black chalk highlighted
with white.

Hände.
Schwarze Kreide,
weiß gehöht.

Les mains.
Fusain noir réhaussé
de blanc.

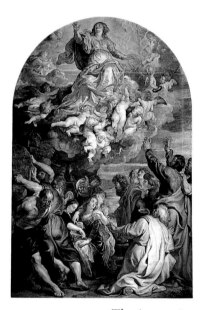

*The Assumption
of Mary.*
Oil on canvas.

Himmelfahrt Mariens.
Öl auf Leinwand.

Assomption de Marie.
Huile sur toile.

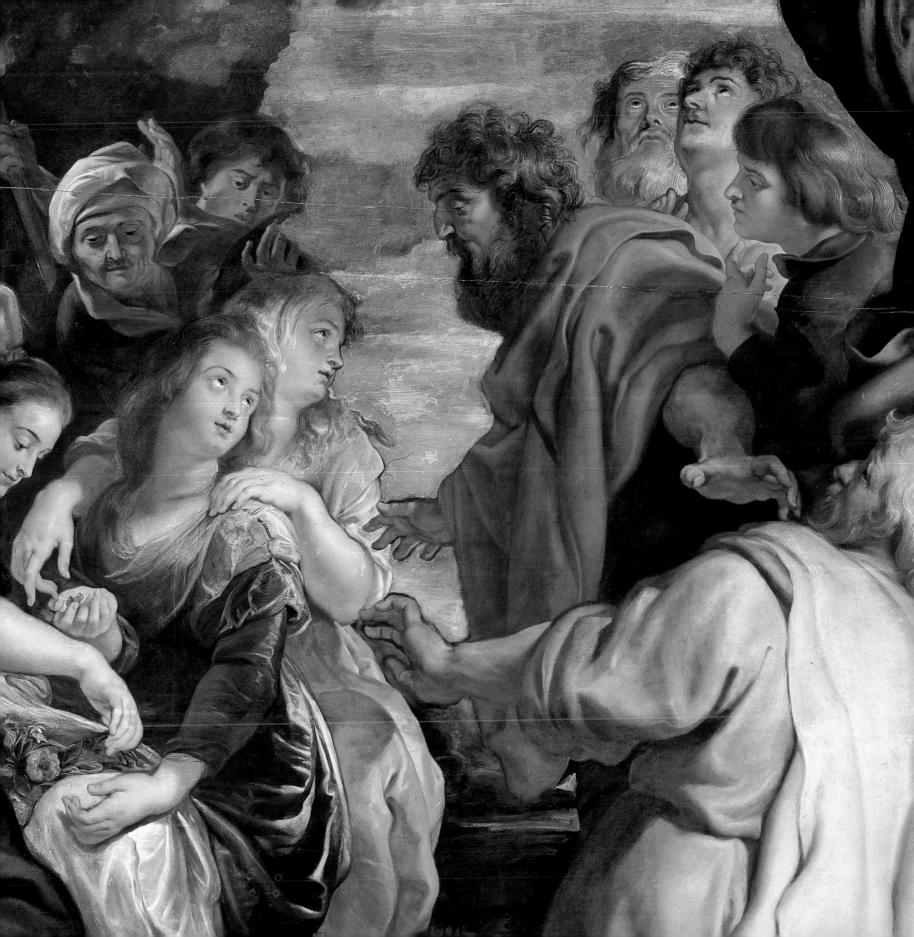

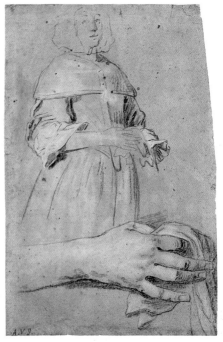

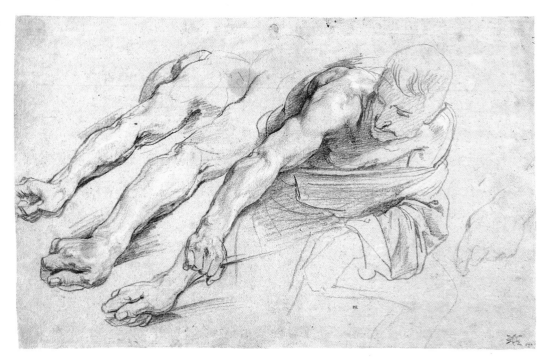

Study of figure and hand.
Charcoal on paper.

*Studie einer Figur
und einer Hand.*
Kohle auf Papier.

*Étude de silhouette
et de main.*
Fusain sur papier.

*Man leaning with his right arm
outstretched and three studies
of hands and arms.*
Black pastel highlighted with
white on buff paper.

*Sich auf seinen ausgestreckten rechten
Arm stützender Mann und drei
Studien von Händen und Armen.*
Schwarzes Pastell, weiss gehöht
auf Chamoispapier.

*Homme qui se penche avec son
bras droit tendu et trois études de mains.*
Pastel noir, rehauts de pastel blanc,
papier chamois.

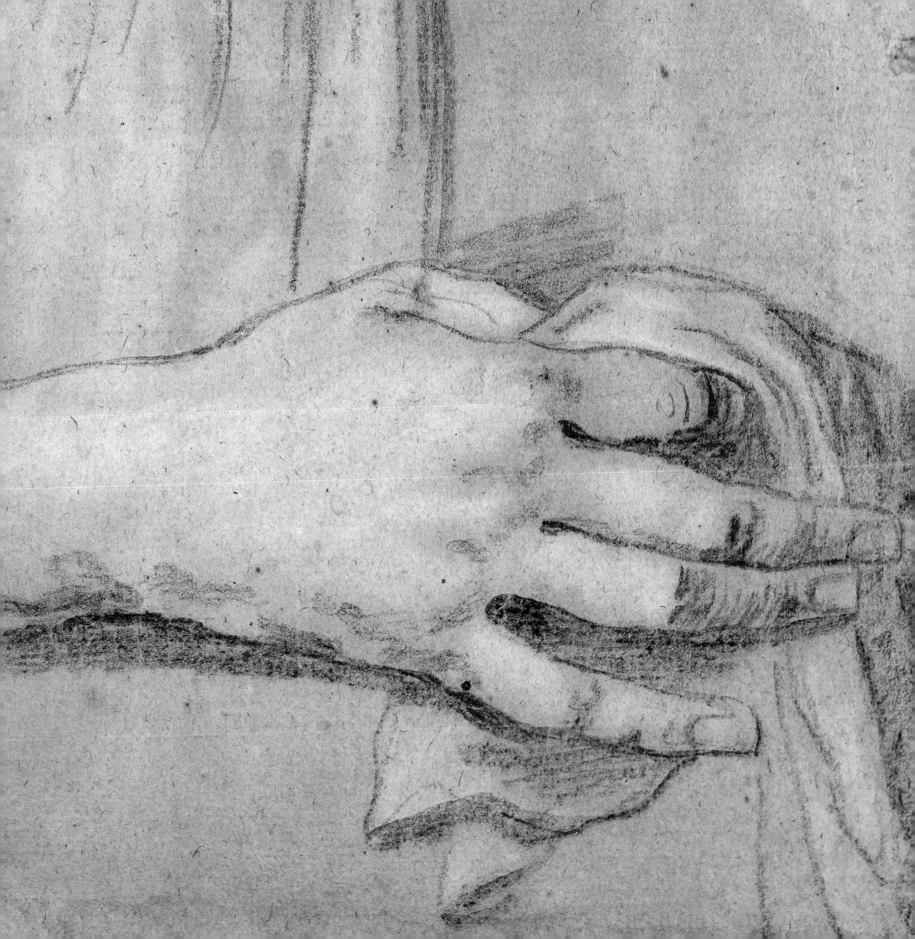

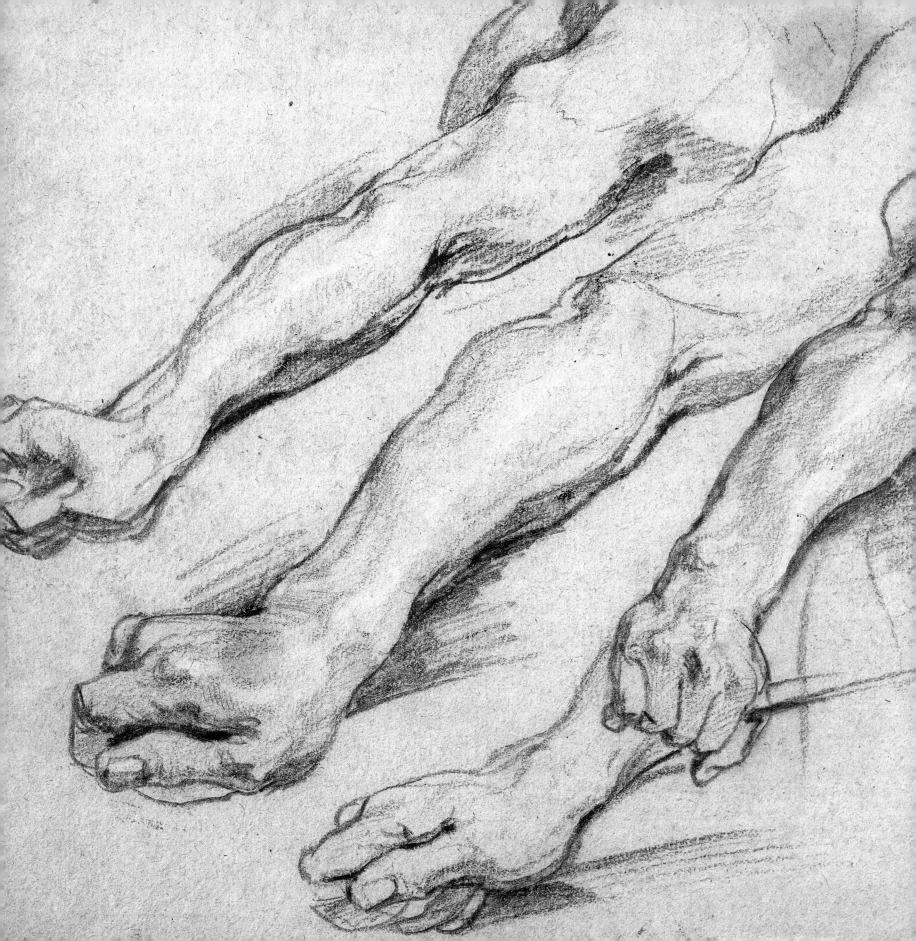

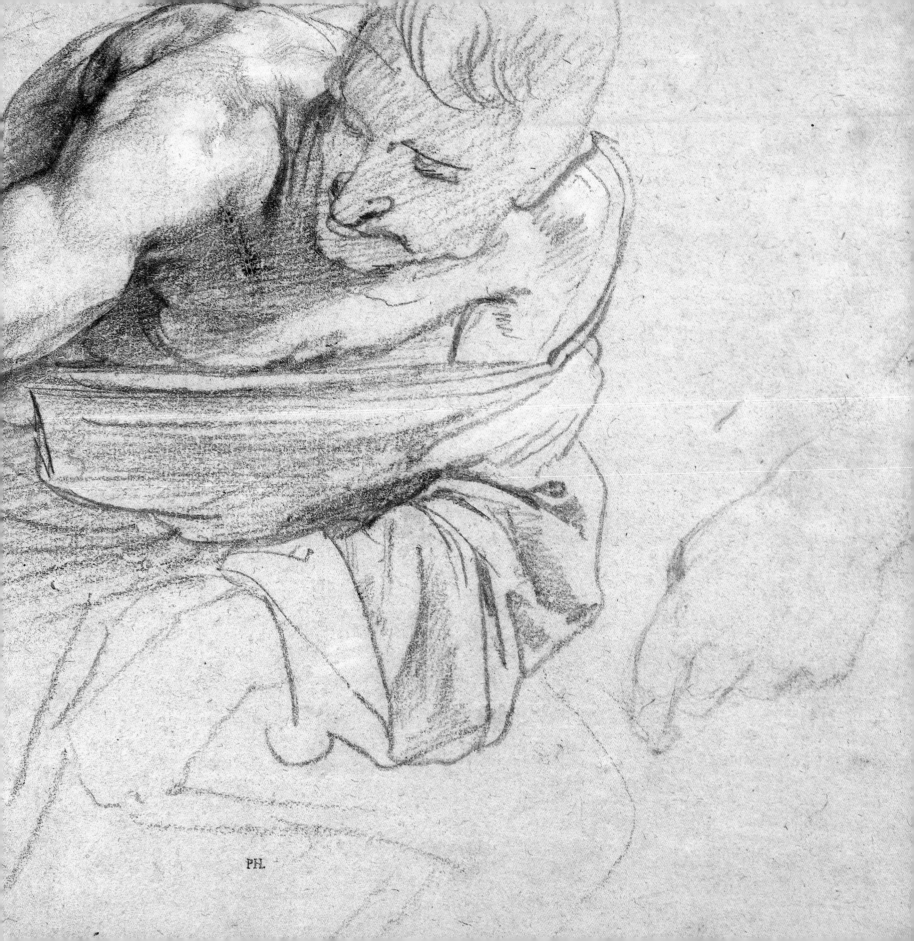

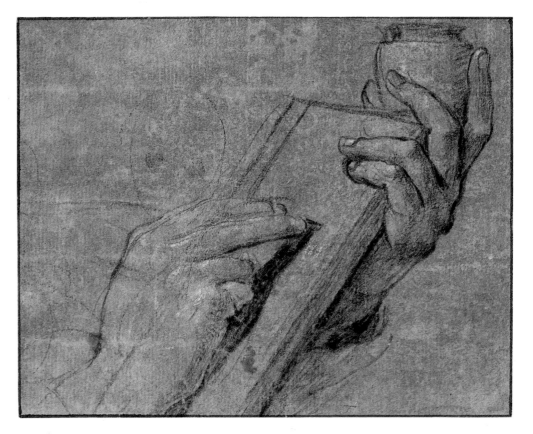

Study of two hands of a man writing.
Black chalk highlighted with
white on grey paper.

*Studien zweier Hände
eines schreibenden Mannes.*
Schwarze Kreide, weiss gehöht
auf grauem Papier.

*Étude de deux mains d'un
homme écrivant.*
Pierre noire, rehauts de blanc,
papier gris.

*Saint Paul preaching
in Ephesus.*
Oil on canvas.

*Die Predigt des heiligen
Paulus in Ephesos.*
Öl auf Leinwand.

*La prédication de
saint Paul à Ephèse.*
Huile sur toile.

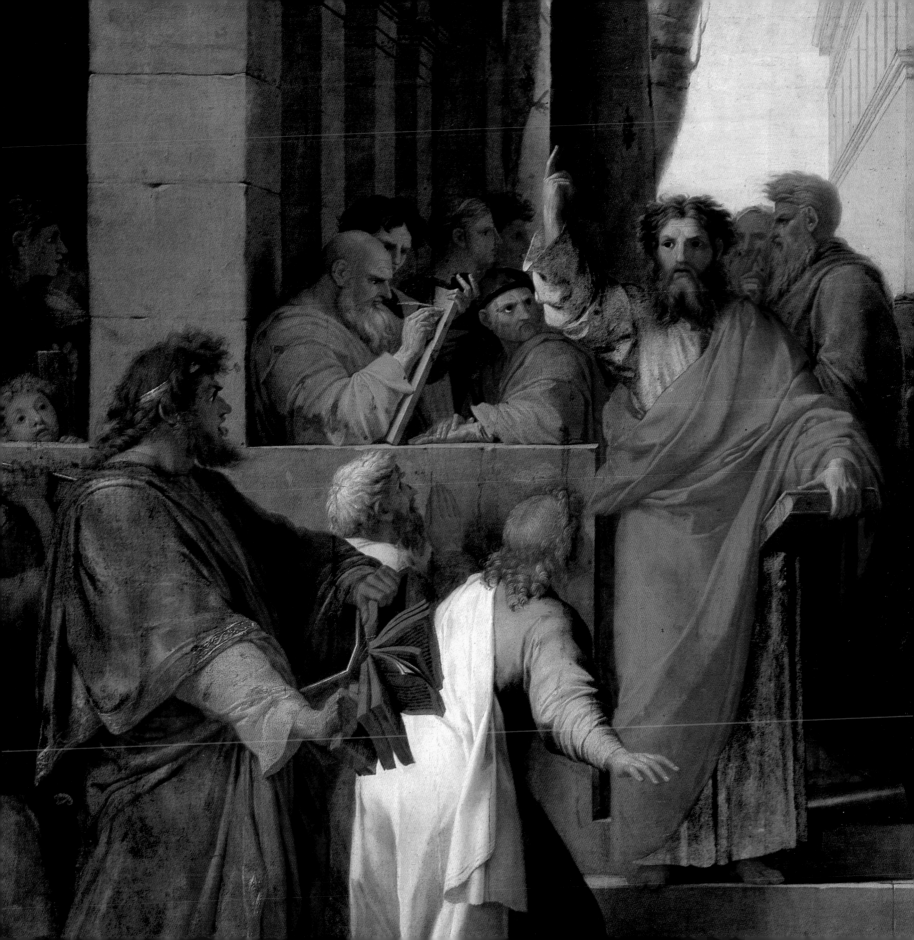

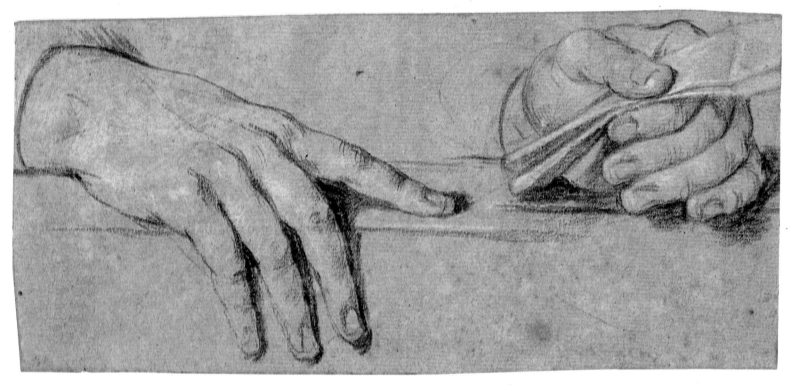

*Study of two hands, one laid on a
ledge, the other holding a letter.*
Black chalk highlighted
with white chalk.

*Studie zweier Hände, eine
ruht auf einem Sims und die
andere hält einen Brief.*
Schwarze Kreide, mit weisser
Kreide gehöht.

*Étude de deux mains,
l'une posée sur un rebord,
l'autre tenant une lettre.*
Pierre noire, rehauts de craie blanche.

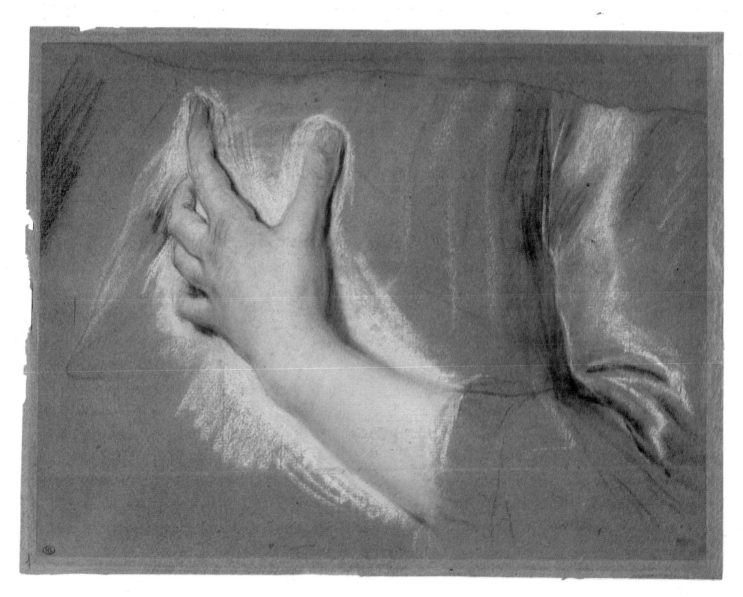

Study of a woman's left arm.
Pastel and black chalk on blue paper.

Studie eines linken Frauenarms.
Pastell und schwarze Kreide auf bläulichem Papier.

Étude d'un bras gauche de femme.
Pastel, pierre noire, sur papier bleu.

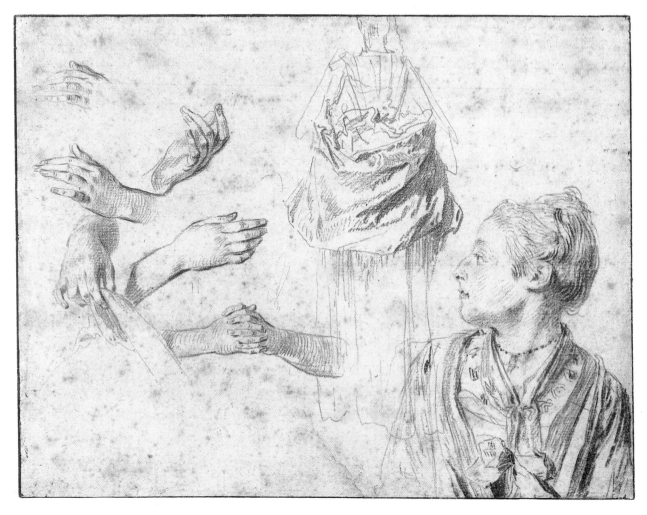

Six studies of hands, two of them crossed over, standing woman seen from
behind, bust of woman in profile, head turned to the left.
Red chalk and black chalk.

Sechs Studien von Händen, von denen sich zwei überschneiden,
Rückansicht einer Frau, Frauenbüste im Profil mit nach links gedrehtem Kopf.
Rötel und schwarze Kreide.

Six études de mains dont deux entrecroisées, femme debout
vue de dos, femme en buste vue de profil, la tête tournée vers la gauche.
Sanguine, pierre noire.

*Figure of a musician playing the bass
viol, at a three-quarters' angle,
slightly turned to the left.*
Red chalk and black chalk.

*Figur eines auf der Bassviola
spielenden Musikers in Dreiviertelansicht,
leicht nach links gedreht.*
Rötel und schwarze Kreide.

*Musicien jouant du violoncelle vue
de trois quart sur la gauche.*
Sanguine et pierre noire.

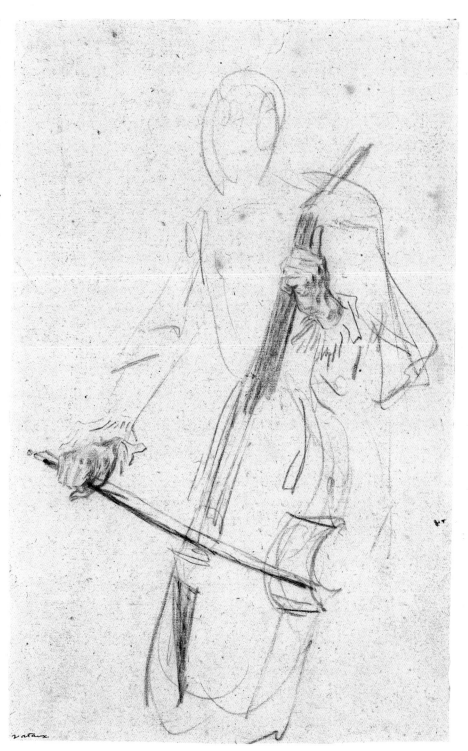

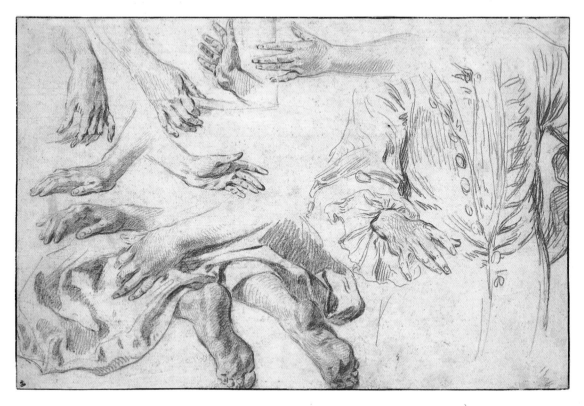

*Sheet of studies, eight hands, feet of a
kneeling figure, a man's bust,
the right hand foremost.*
Red chalk.

*Studienblatt mit acht Händen
und Füßen einer knienden Figur
sowie männliche Büste mit
vorgestreckter rechter Hand.*
Rötelzeichnung.

*Feuille d'études, huit mains, pieds d'une
figure agenouillée, buste d'homme,
la main droite en avant.*
Sanguine.

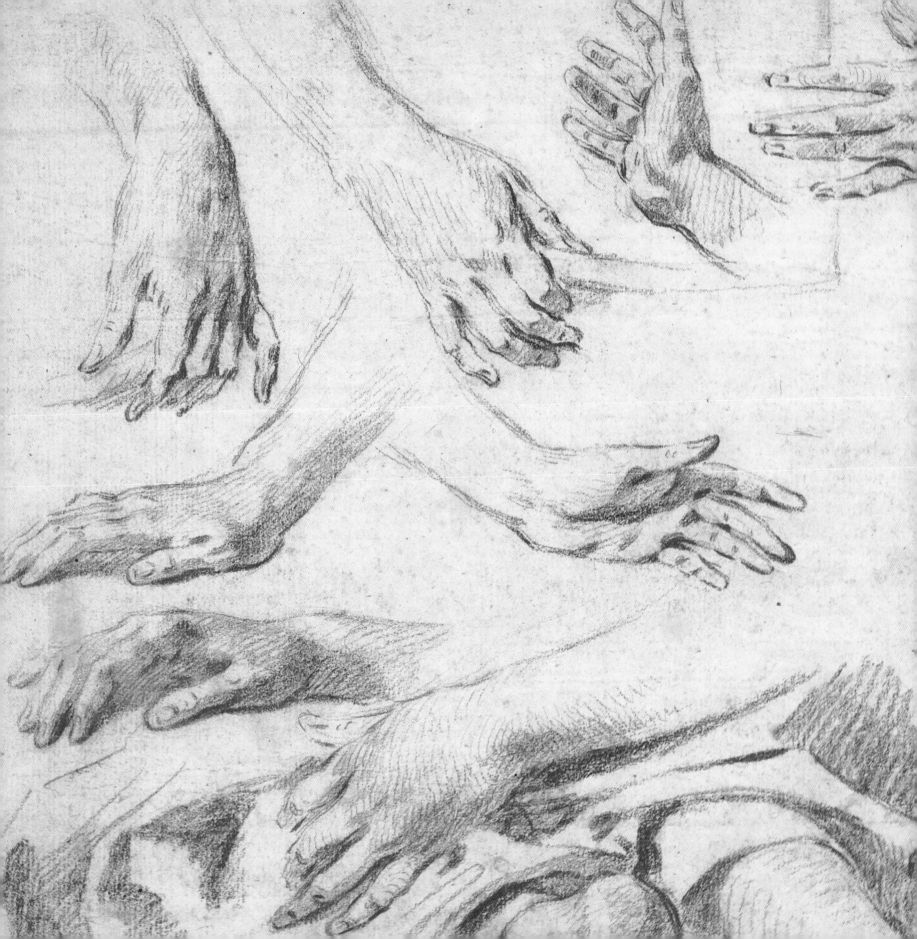

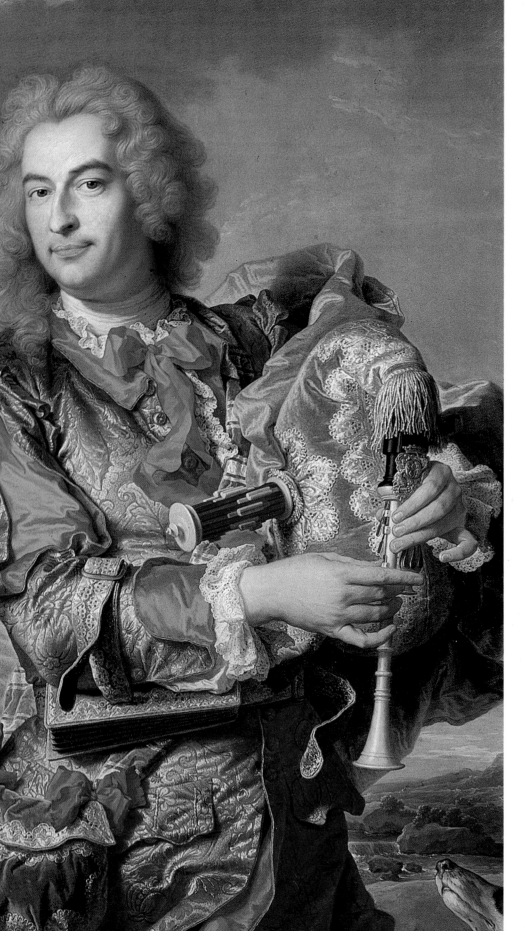

HYACINTHE RIGAUD

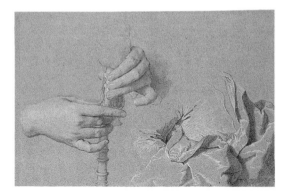

*Studies of hands playing the musette
and a man's draped torso.*
Black and white pastel on blue paper.

*Studien von Musette spielenden Händen
und männlicher, drapierter Torso.*
Schwarzes und weisses Pastell auf blauem Papier.

*Feuille d'études de mains jouant
de la musette et torse d'homme drapé.*
Pastel noir et blanc sur papier bleu.

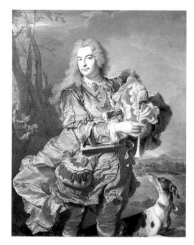

*Portrait of President
Gaspard de Gueidan
as a musette player.*
Oil on canvas.

*Porträt des Präsidenten
Gaspard de Gueidan als
Musette-Spieler.*
Öl auf Leinwand.

*Portrait du président
Gaspard de Gueidan en
joueur de musette.*
Huile sur toile.

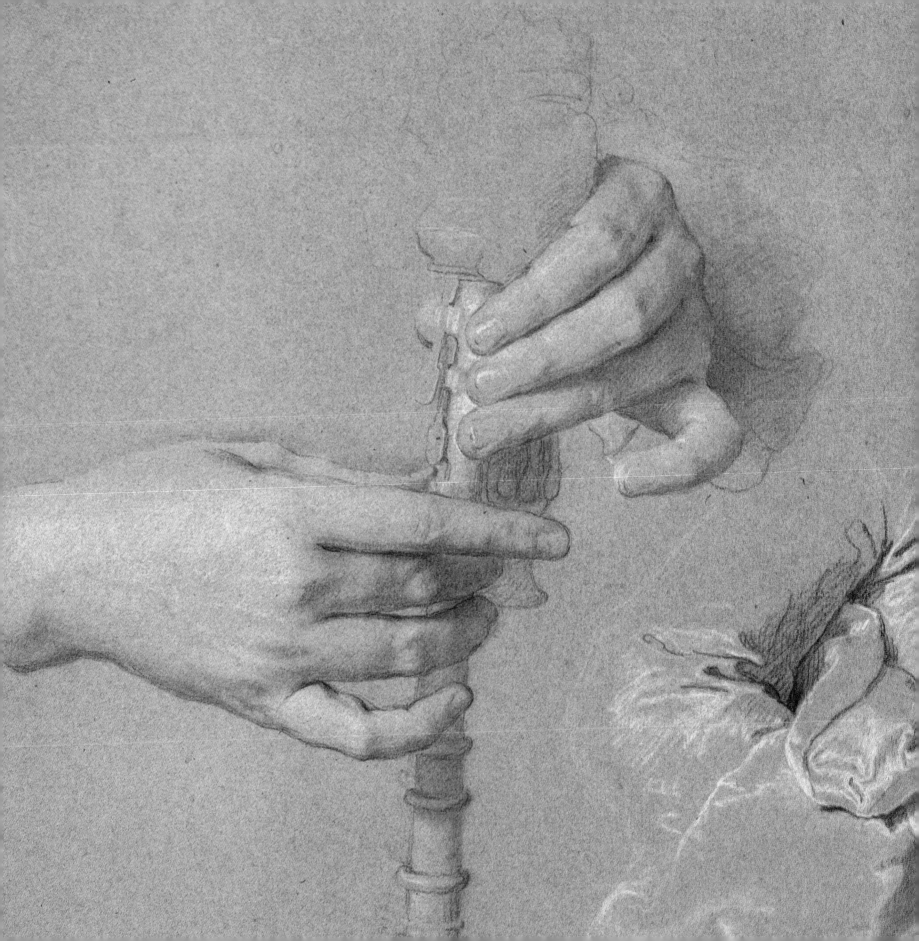

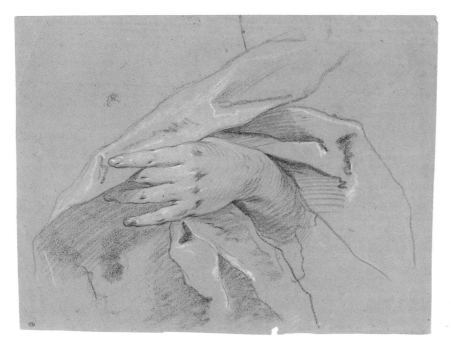

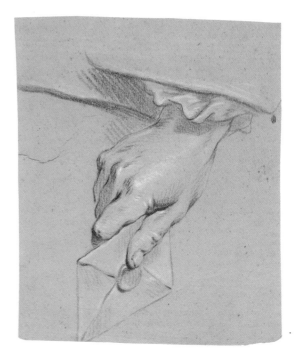

*Study of a hand pulling aside
the fold of a curtain.*
Red chalk with white highlights
on grey paper.

*Studie einer Hand, die Falte
einer Draperie wegschiebend.*
Rötel und schwarzer Stift, weiss gehöht
auf grauem Papier.

*Étude d'une main écartant
le pli d'une draperie.*
Sanguine, rehauts de blanc,
papier gris.

Study of a hand holding a letter.
Three crayons on beige paper.

*Studie einer einen Brief
haltenden Hand.*
drei verschiedene Stifte
auf beigem Papier.

*Étude d'une main
tenant une lettre.*
trois crayons,
papier beige.

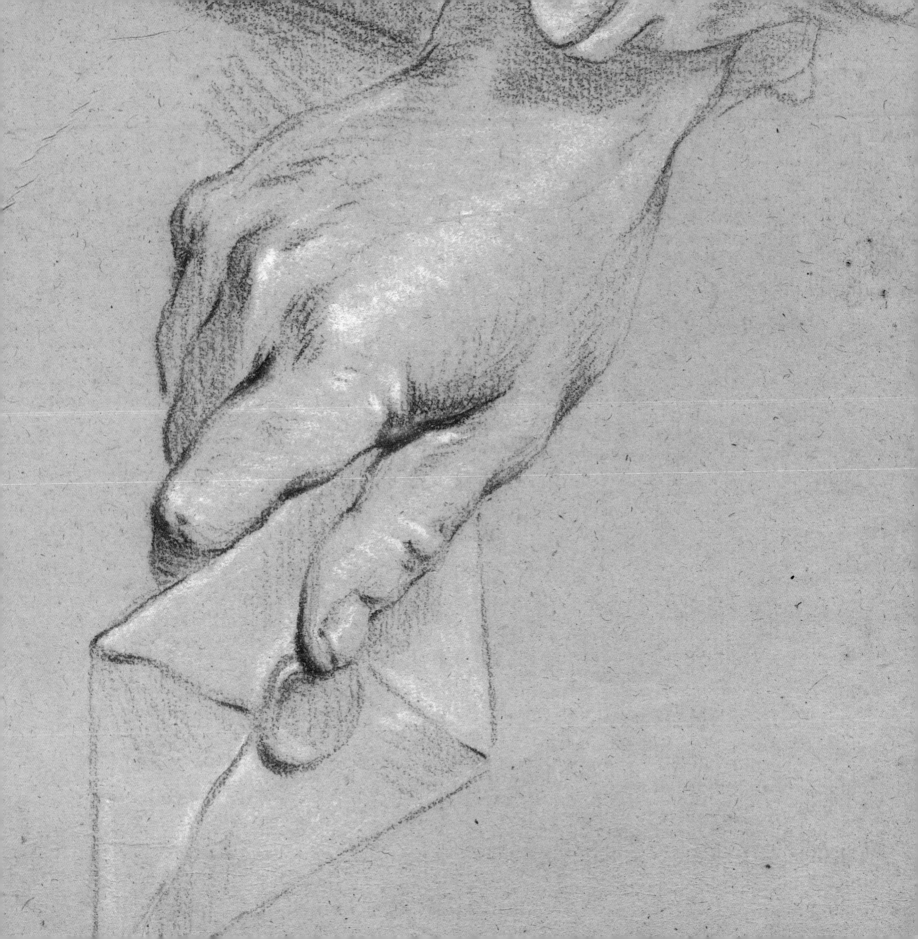

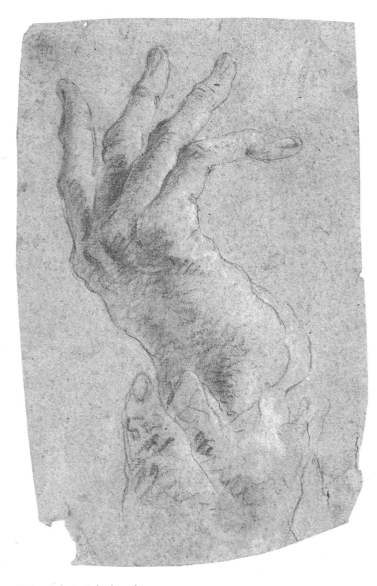

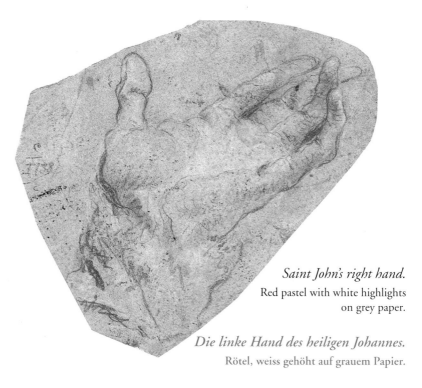

Saint John's right hand.
Red pastel with white highlights
on grey paper.

Die linke Hand des heiligen Johannes.
Rötel, weiss gehöht auf grauem Papier.

La main gauche de saint Jean.
Sanguine avec rehauts de blanc
sur papier gris.

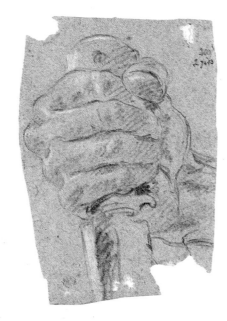

Hand holding a dagger.
Black and blue pastel.

*Einen Dolch
umfassende Hand.*
Schwarzes und blaues Pastell.

*Main empoignant
une dague.*
Pastel noir et bleu.

Saint John's right hand.
Red pastel with white highlights on grey paper.

Die rechte Hand des heiligen Johannes.
Rötel, weiss gehöht auf grauem Papier.

La main droite de saint Jean.
Sanguine avec rehauts de blanc sur papier gris.

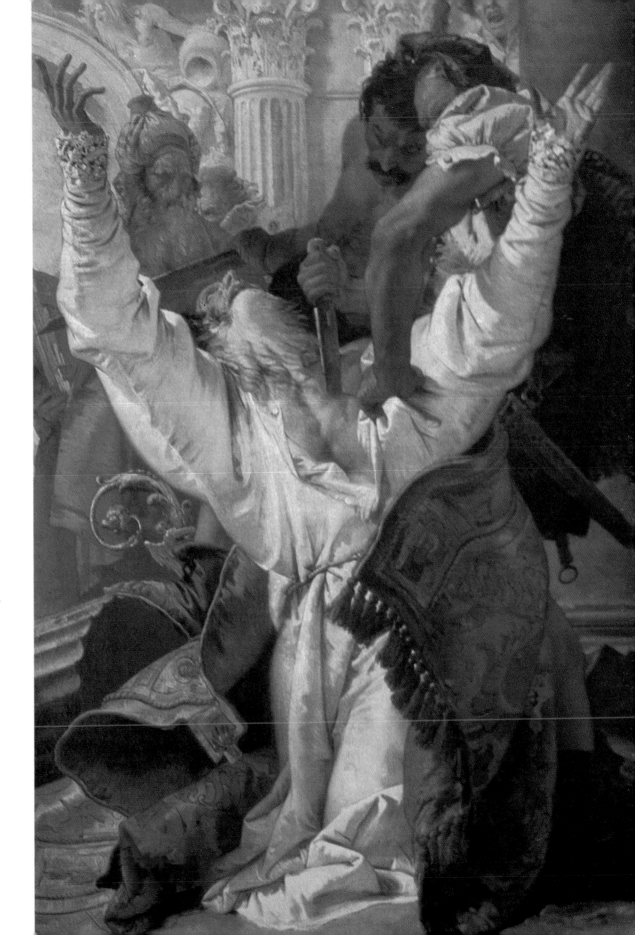

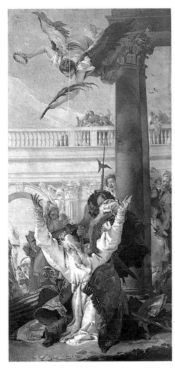

The Martyrdom of Saint John,
Bishop of Bergamo.
Oil on canvas.

Das Martyrium des heiligen
Johannes, Bischof
von Bergamo.
Öl auf Leinwand.

Le martyre de saint Jean,
évêque de Bergame.
Huile sur toile.

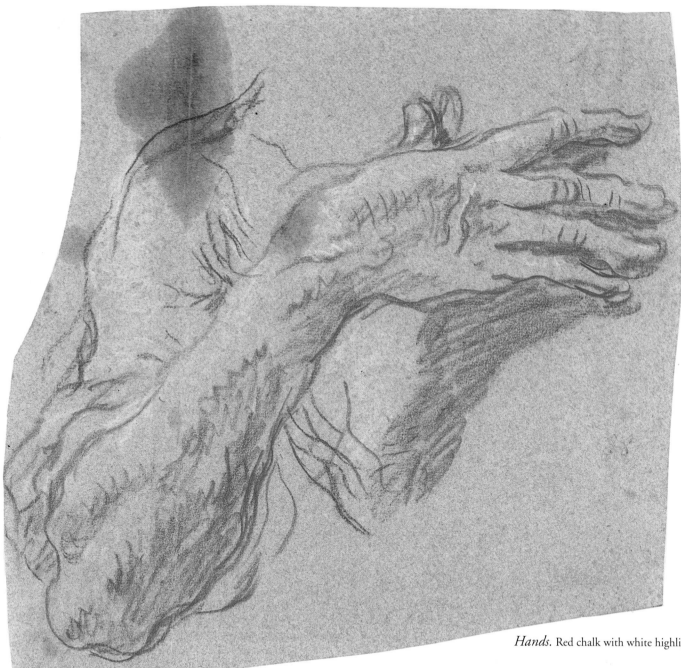

Hands. Red chalk with white highlights on blue paper.

Hände. Rötel, weiss gehöht auf blauem Papier.

Mains. Sanguine avec rehauts de blanc sur papier bleu.

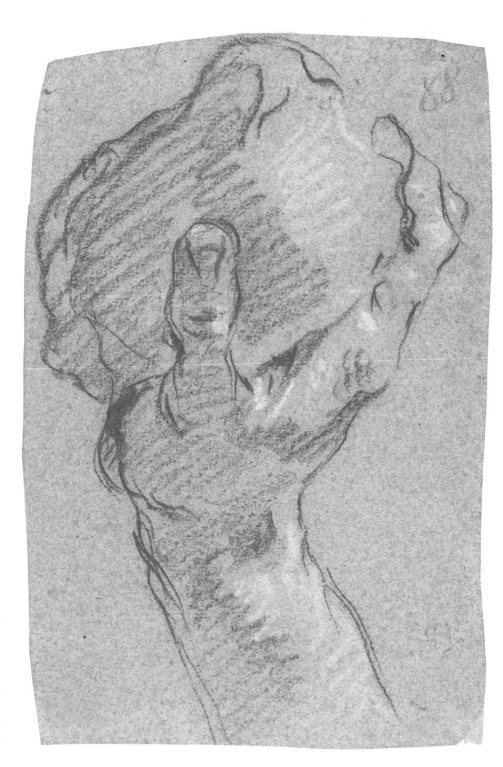

A hand holding a stone.
Red chalk with white highlights
on blue paper.

Hand, einen Stein haltend.
Rötel, weiss gehöht, auf blauem Papier.

Une main tenant une pierre.
Sanguine et rehauts de blanc sur papier bleu.

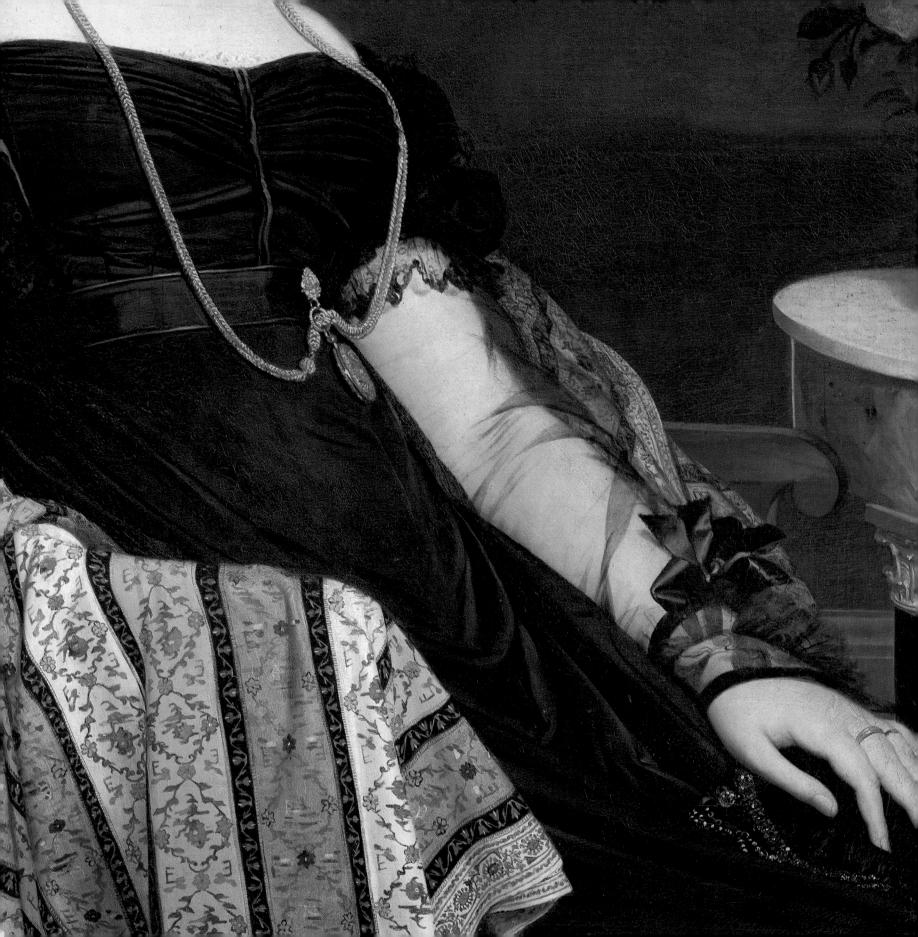

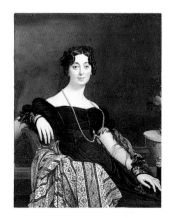

*Madame Leblanc
(Françoise Poncelle).*
Oil on canvas.

*Madame Leblanc
(Françoise Poncelle).*
Öl auf Leinwand.

*Madame Leblanc
(Françoise Poncelle).*
Huile sur toile.

*Madame
Leblanc's left hand.*
Graphite on tracing paper.

*Linke Hand von
Madame Leblanc.*
Bleistift auf Pauspapier.

*Main gauche
de madame Leblanc.*
Mine de plomb sur
papier calque.

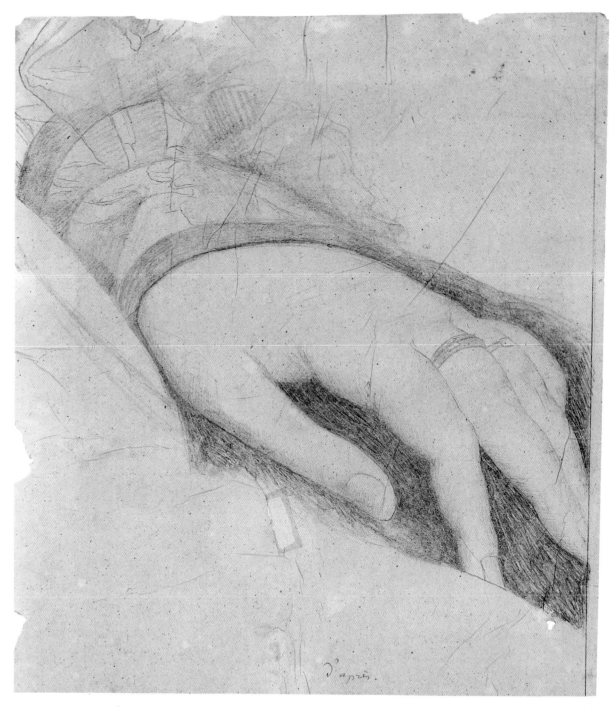

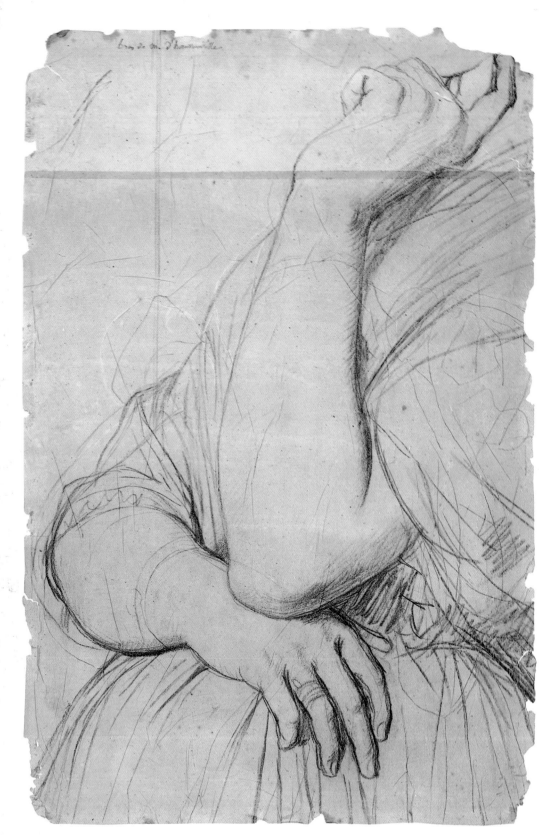

The Comtesse
d'Haussonville's arm.
Black chalk on two
sheets of tracing paper.

*Arm der Comtesse
d'Haussonville.*
Schwarze Kreide auf zwei
Pauspapier-Blätter.

*Bras de la comtesse
d'Haussonville.*
Pierre noire sur
deux calques.

JEAN-AUGUSTE-DOMINIQUE INGRES

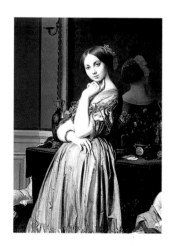

*The Comtesse
d'Haussonville.*
Oil on canvas.

*Die Comtesse
d'Haussonville.*
Öl auf Leinwand.

*La comtesse
d'Haussonville.*
Huile sur toile.

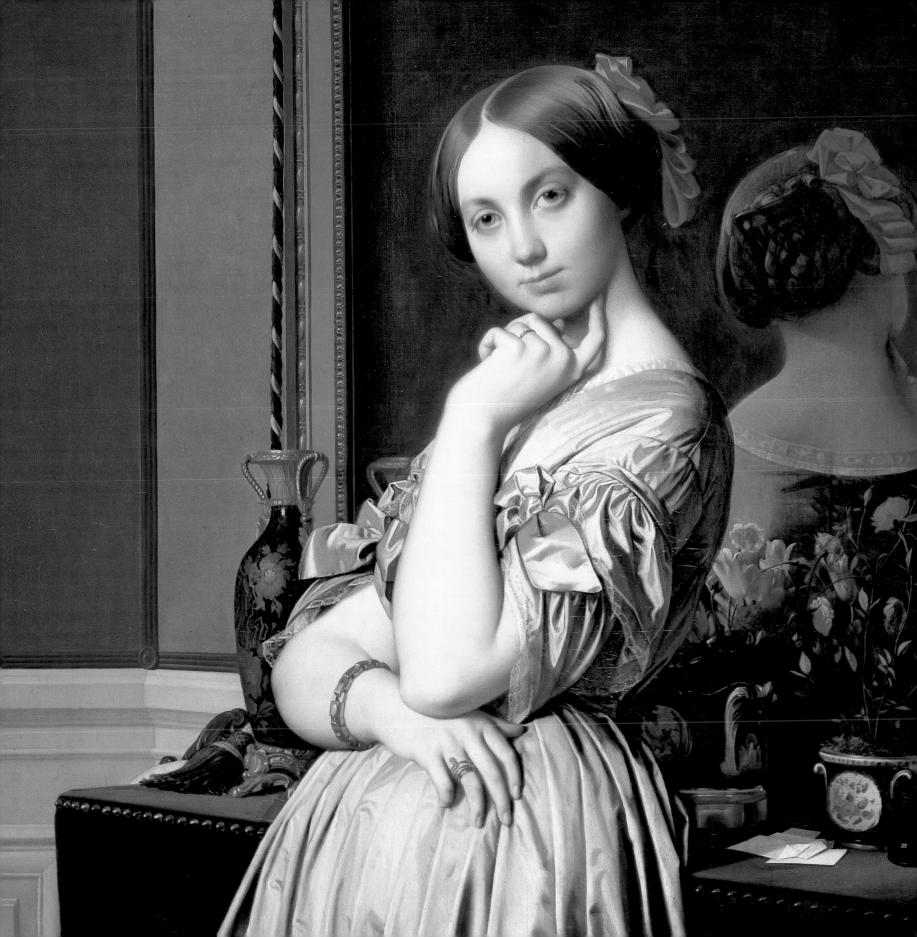

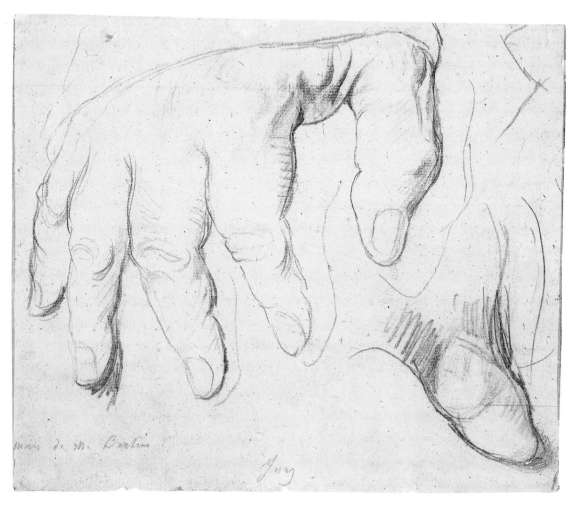

Portrait of
Louis-François Bertin.
Oil on canvas.

Porträt von
Louis-François Bertin.
Öl auf Leinwand.

Portrait de
Louis-François Bertin.
Huile sur toile.

Study for Monsieur
Bertin's right hand.
Graphite on tracing paper.

Studie zur rechten Hand von
Monsieur Bertin.
Bleistift auf Pauspapier.

Étude pour la main droite
de monsieur Bertin.
Mine de plomb sur papier calque.

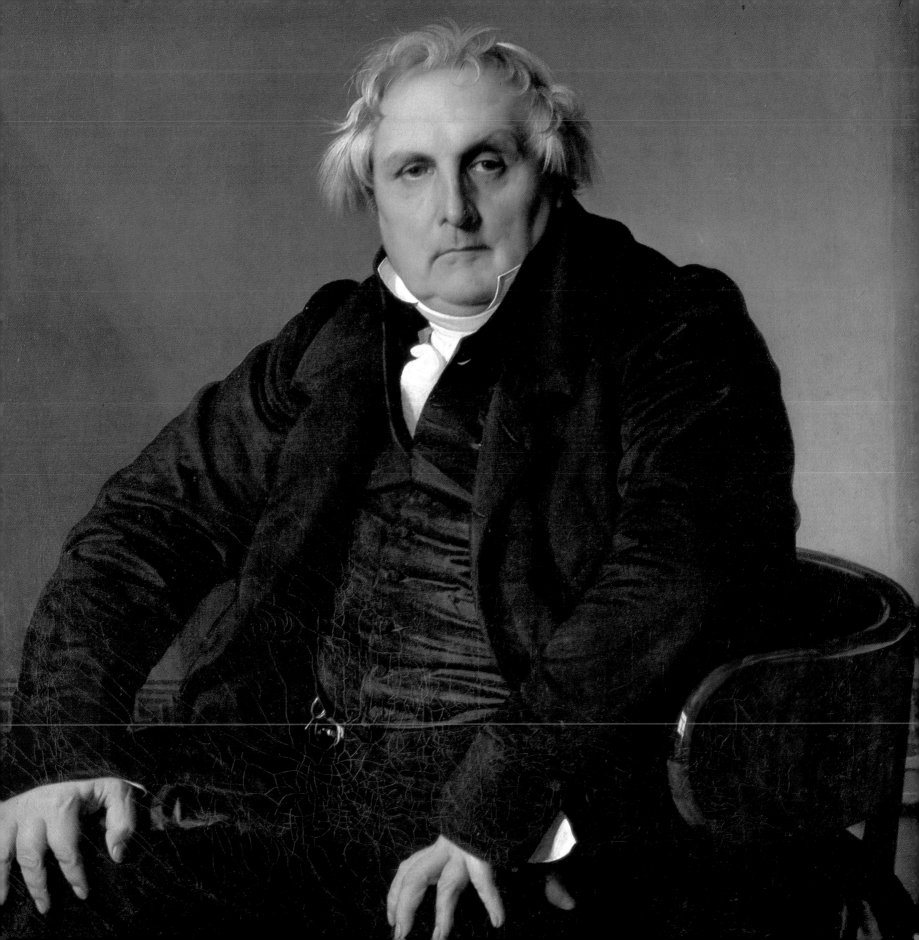

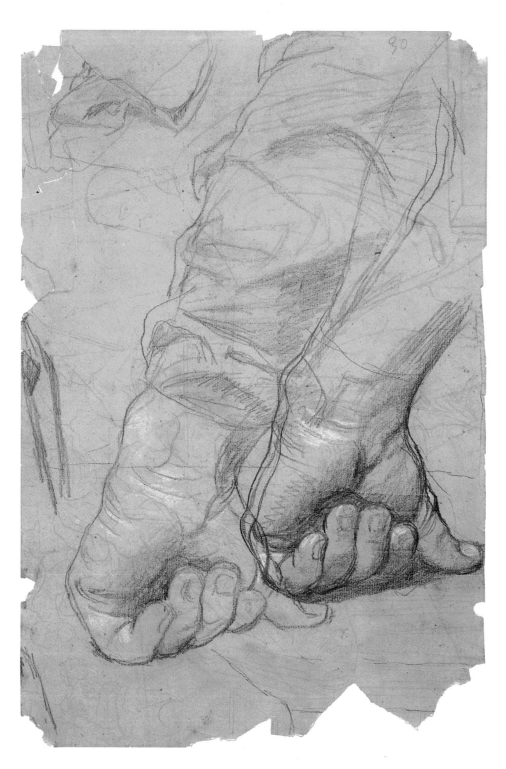

Double study of left hand, study for
the painting *"Jesus Among the Doctors".*
Graphite and chalk on woven paper.

Doppelstudie einer linken Hand;
Studie für das Gemälde
„*Jesus unter den Schriftgelehrten*".
Bleistift und Kreide auf Faserpapier.

"Jésus au milieu des docteurs".
Double étude de main gauche ;
Mine de plomb et pastel
sur papier fibreux.

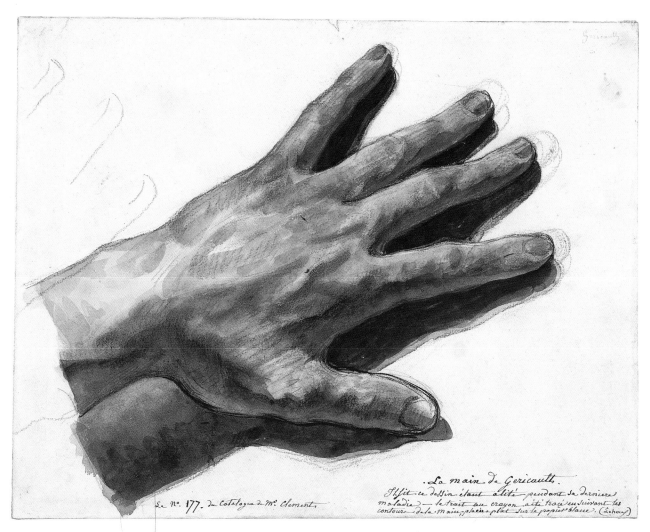

The artist's left hand.
Black chalk, red chalk and
watercolours.

Linke Hand des Künstlers.
Schwarze Kreide, Rötel und Wasserfarbe.

Main gauche de l'artiste.
Fusain, sanguine et aquarelle.

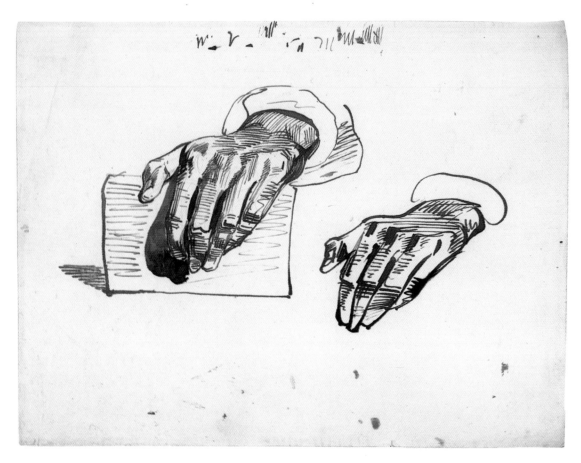

*Two studies
of the left hand.*
Pen and ink.

*Zwei Studien einer
linken Hand.*
Federzeichnung.

*Deux études
de main gauche.*
Plume.

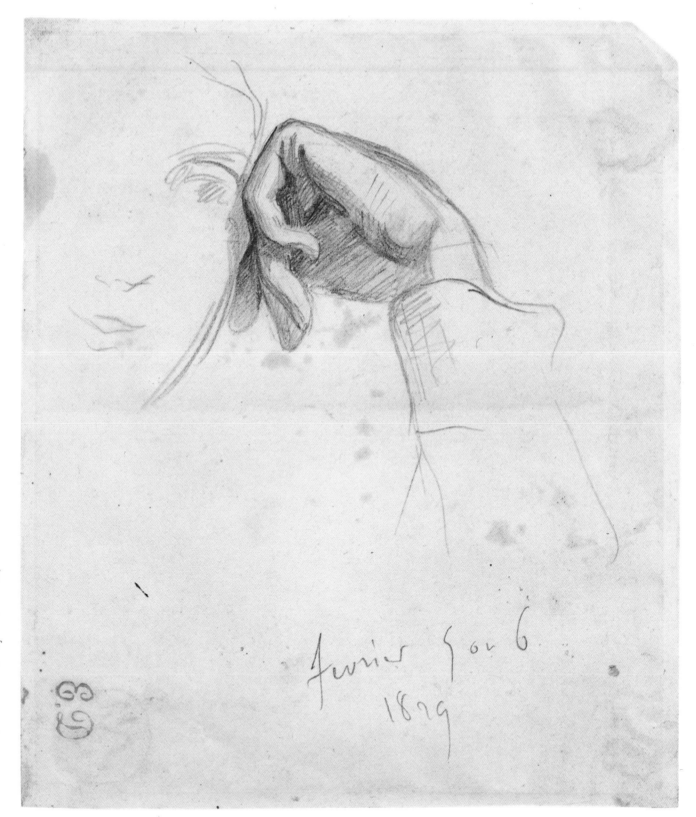

Woman's head, hand against her cheek.
Graphite.

Frauenkopf mit an die Wange gehaltener Hand.
Bleistift.

Tête de femme, la main contre la joue.
Mine de plomb.

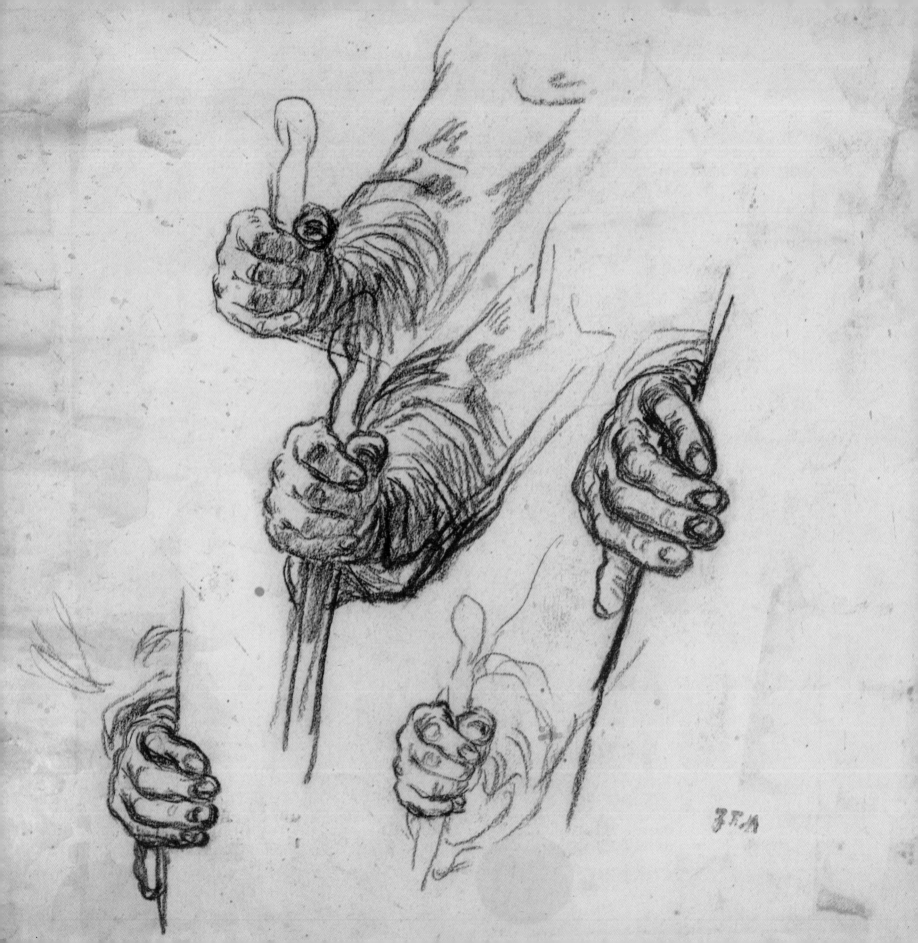

JEAN-FRANÇOIS MILLET

Tobias, or Waiting.
Oil on canvas.

*Tobias oder
die Erwartung.*
Öl auf Leinwand.

Tobie ou l'attente.
Huile sur toile.

Study of hands.
Black chalk.

Studie von Händen.
Schwarze Kreide.

*Étude de deux
mains croisées.*
Fusain.

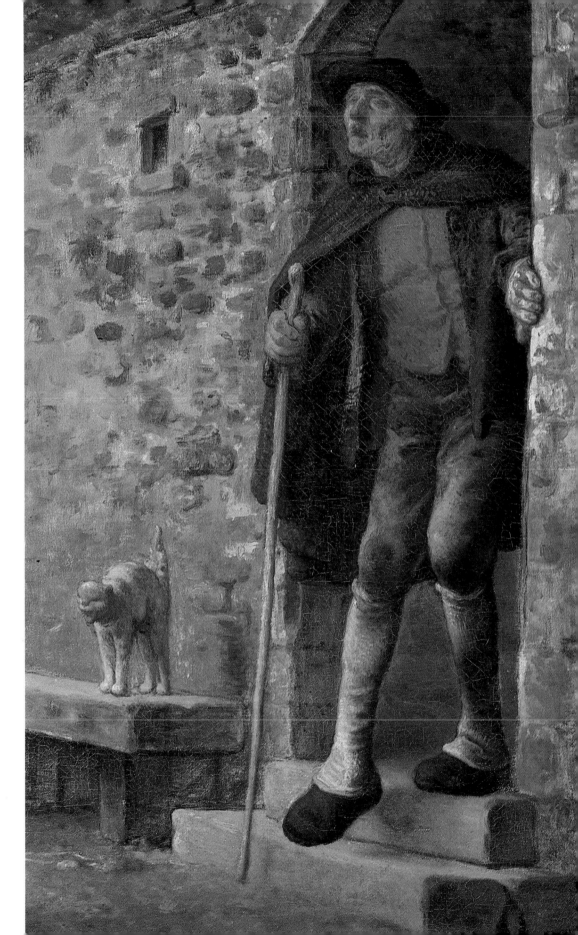

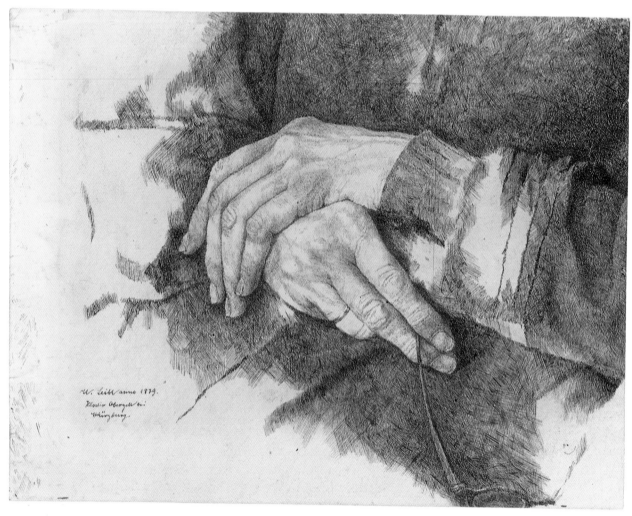

The artist's mother's.
Indian ink.

*Die Hände der
Mutter des Künstlers.*
Tusche.

Les mains de la mère de l'artiste.
Encre de chine.

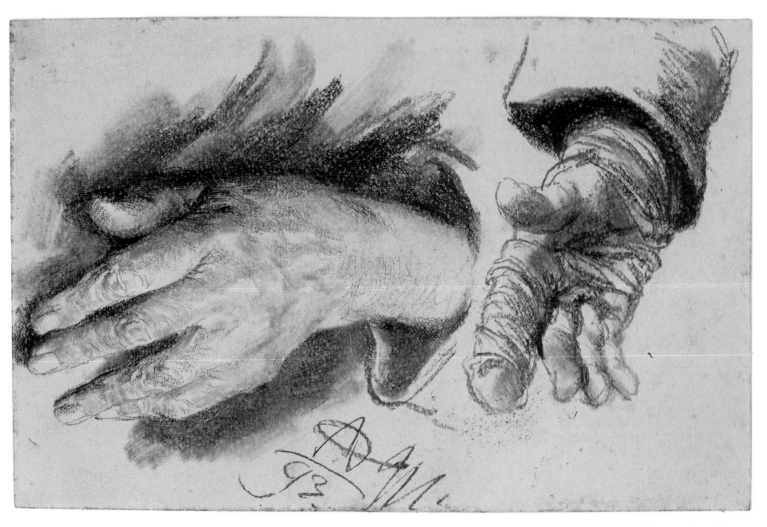

*Two studies of hands,
one wearing a bandage.*
Stump drawing and black chalk.

*Zwei Studien von Händen,
davon eine mit Verband.*
Estampe und schwarze Kreide.

*Deux études de mains, dont une
porte un pansement.*
Estampe, pierre noire.

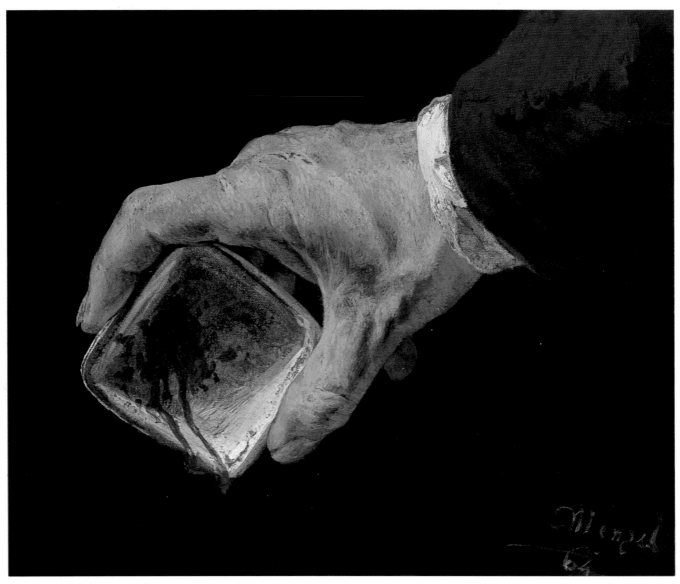

The artist's right hand holding a mixing bowl.
Gouache.

Die rechte Hand des Künstlers, ein Glas haltend.
Gouache.

La main de l'artiste tenant un récipient.
Gouache.

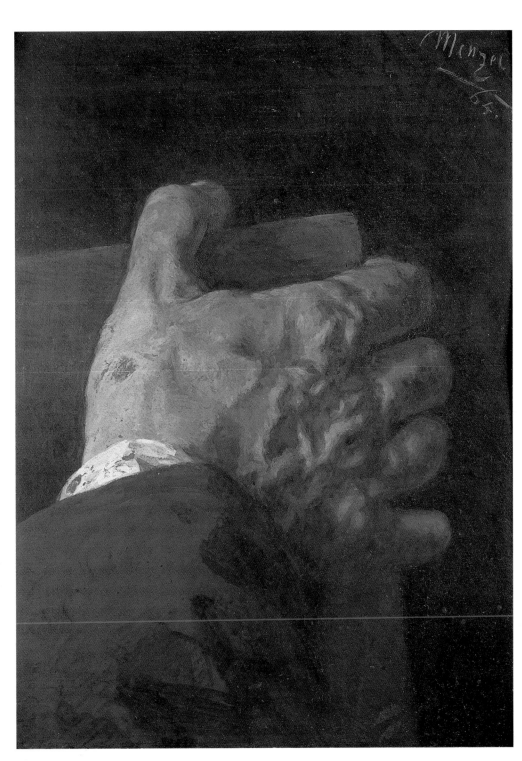

*The artist's right hand
holding a book.*
Gouache.

*Die rechte Hand des
Künstlers, ein Buch haltend.*
Gouache.

*La main droite de l'artiste
tenant un livre.*
Gouache.

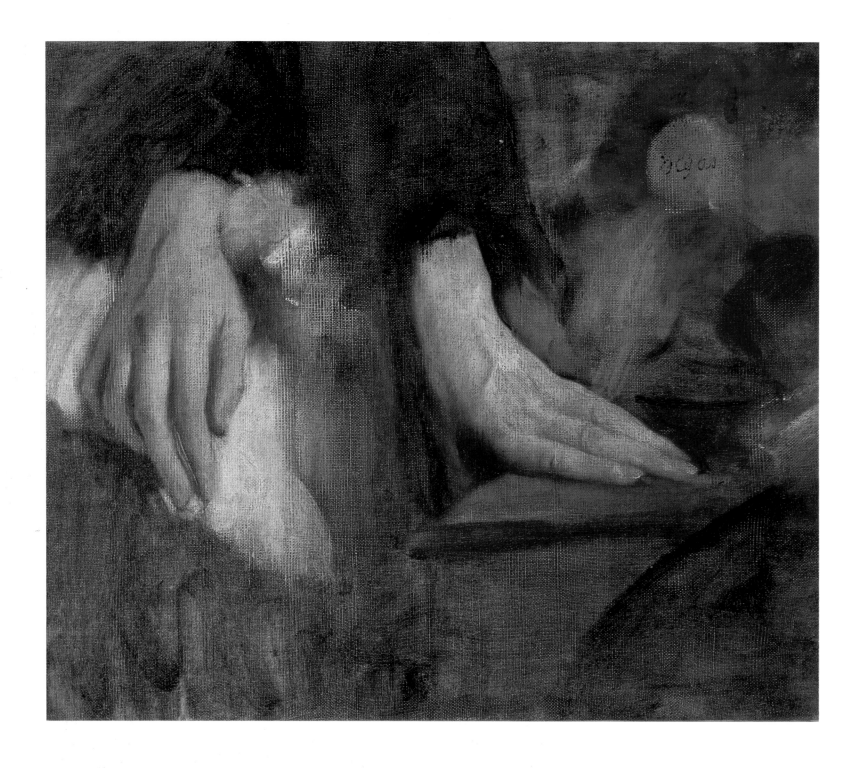

The Bellelli family.
Oil on canvas.

Die Familie Bellelli.
Öl auf Leinwand.

La famille Bellelli.
Huile sur toile.

*Study of hands for
the Bellelli family.*
Oil on canvas.

*Studie von Händen
für das Bild
der Familie Bellelli.*
Öl auf Leinwand.

*Étude de mains pour
la famille Bellelli.*
Huile sur toile.

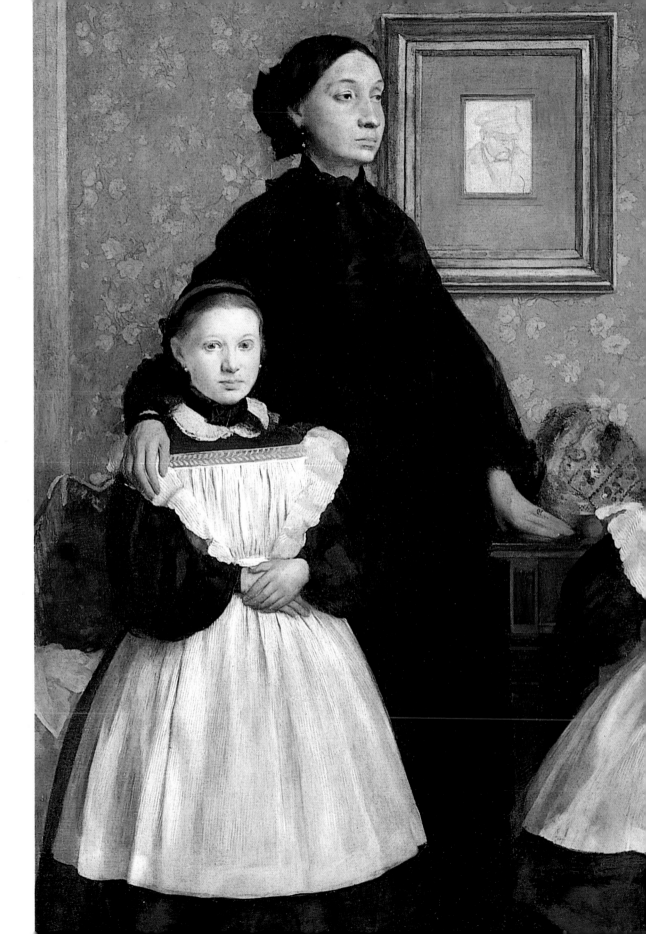

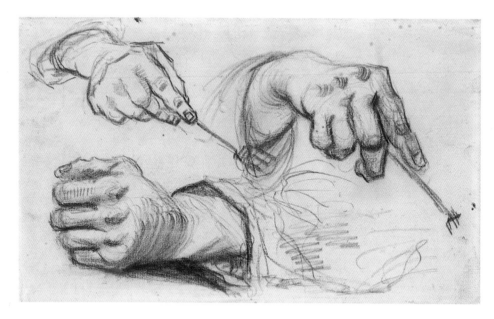

Study for the Potato Eaters.
Black crayon.

Studie für die Kartoffelesser.
Schwarzer Stift.

*Étude pour les mangeurs
de pommes de terre.*
Crayon noir.

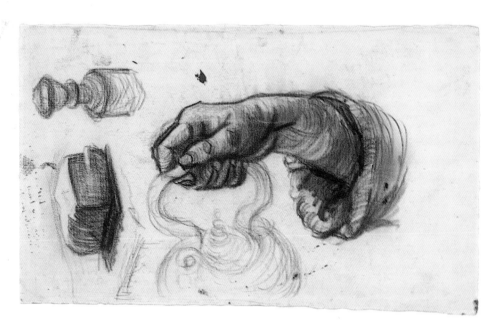

*Study of a hand
holding a coffee pot.*
Black crayon on dutch paper.

*Studie einer Hand, eine
Kaffeetasse haltend.*
Schwarzer Stift.

*Étude d'une main
tenant une cafetière.*
Crayon noir sur papier.

The Potato Eaters.
Oil on canvas.

Die Kartoffelesser.
Öl auf Leinwand.

*Les mangeurs de
pommes de terre.*
Huile sur toile.

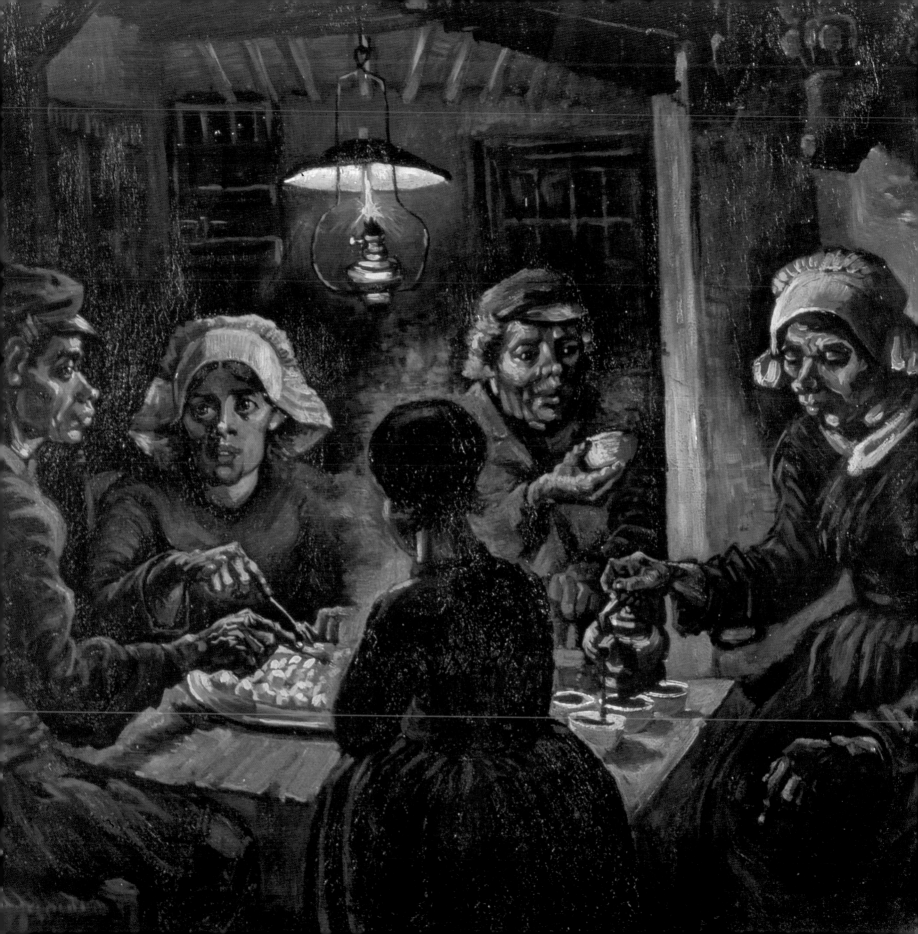

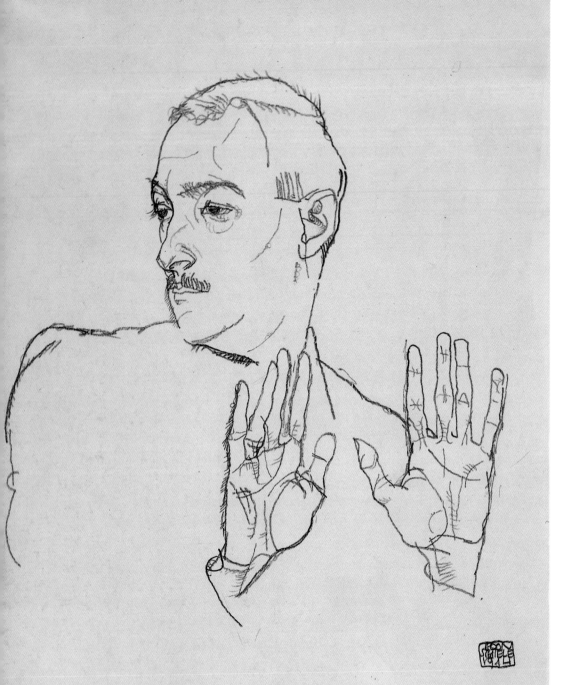

Portrait of the art critic
Arther Roessler.
Crayon.

Bildnis des Kunstkritikers
Arthur Roessler.
Graphitstift.

Portrait du critique d'art
Arthur Roessler.
Crayon.

Study of hands.
Black crayon.

Studie von Händen.
Schwarzer Stift.

Étude de mains.
Crayon noir.

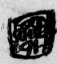

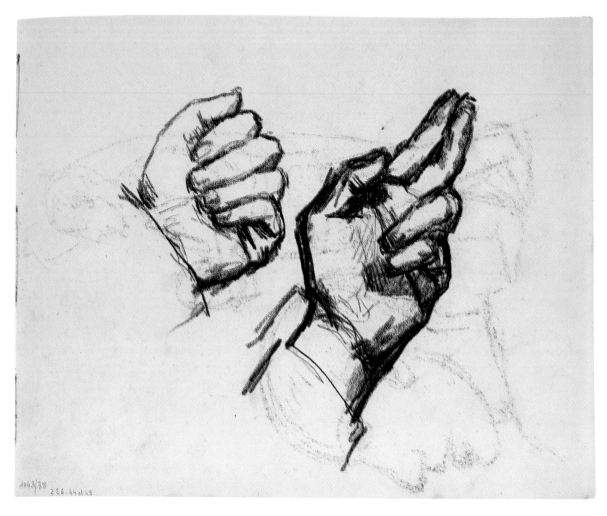

*Sketchbook, Demoiselles
d'Avignon : study of hands.*
Black crayon.

*Zeichenheft, Handstudien zu den
„Demoiselles d'Avignon".*
Schwarzer Stift.

*Carnet de dessins, Demoiselles
d'Avignon : études de mains.*
Crayon noir.

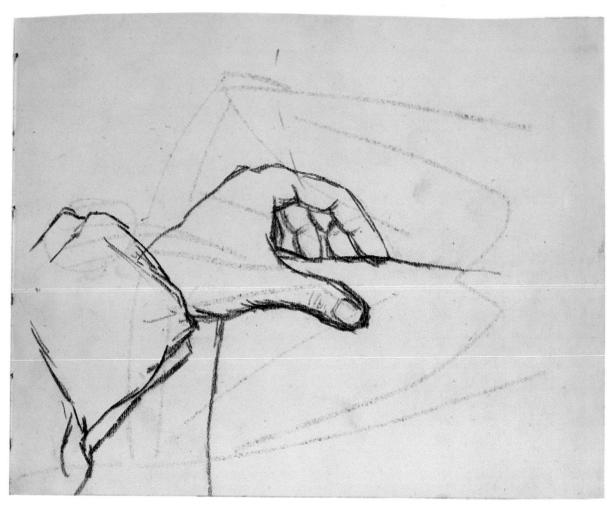

*Sketchbook number 9 : study of
medical student holding a book.*
Black crayon.

*Zeichenheft Nr. 9, Studie zum
Medizinstudenten mit einem Buch.*
Schwarzer Stift.

*Carnet de dessins n° 9, étude
pour l'étudiant en médecine,
tenant un livre.*
Crayon noir.

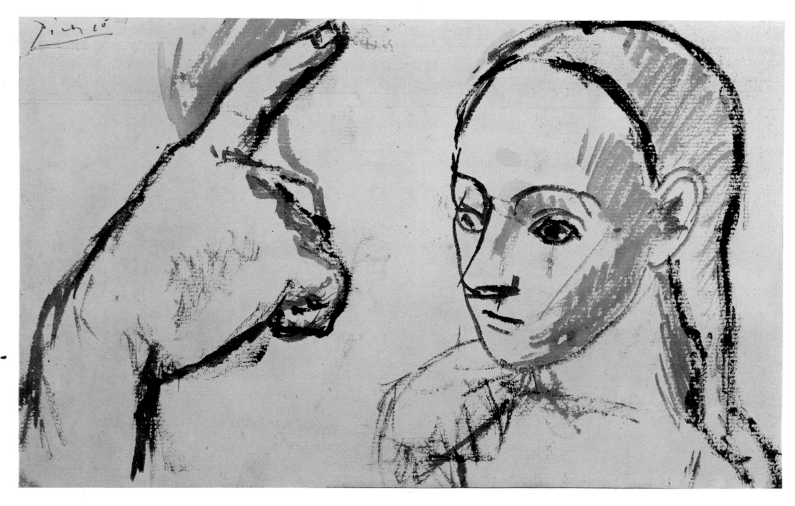

*Study of a woman's
hand and head.*
Watercolours.

*Studie einer Frauenhand
und eines Frauenkopfes.*
Aquarell.

*Étude de main et
de tête de femme.*
Aquarelle sur papier.

The hand.
Watercolours.

Die Hand.
Aquarell.

La main.
Aquarelle.

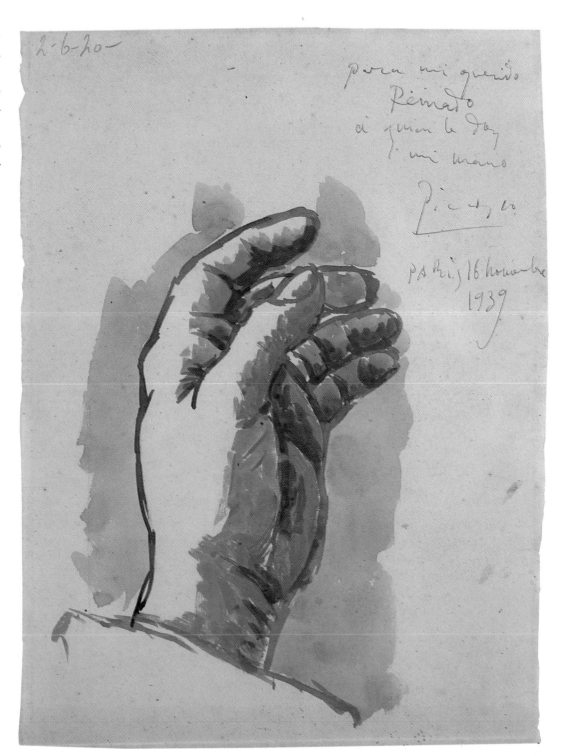